Evaluating Early Lea~~~ in Museums

Evaluating Early Learning in Museums presents developmentally appropriate and culturally relevant practices for engaging early learners and their families in informal arts settings.

Written by early childhood education researchers and a museum practitioner, the book showcases what high-quality educational programs can offer young children and their families through the case study of a program at the High Museum of Art in Atlanta, Georgia. Providing strategies for building strong community partnerships and audience relationships, the authors also survey evaluation tools for early learning programs and offer strategies to help museums around the world to engage young children. At the center of this narrative is the seminal partnership that developed between researchers and museum educators during the evaluation of a program for toddlers. Illuminating key components of the partnership and the resulting evolution of family offerings at the museum, the book also draws parallels to current work being done at other museums in international contexts.

Evaluating Early Learning in Museums illustrates how an interdisciplinary collaboration between researchers and practitioners can improve museum practices. As such, the book will be of interest to researchers and students engaged in the study of museums and early childhood, as well as to practitioners working in museums around the world.

Nicole Cromartie is Director of Education and Programs at the Clyfford Still Museum in Denver, Colorado. Cromartie holds a MA in curatorial practice from California College of the Arts and a BA in art history from the University of Florida. She is a museum educator with interests in early learning in museums, accessibility and inclusion, and interpretation.

Kyong-Ah Kwon, PhD, is Associate Professor in the Department of Instructional Leadership and Academic Curriculum at the University of Oklahoma. She received her doctoral degree in developmental studies at Purdue University. Her research areas include the role of children's experiences at home and at school in their development and learning and the early childhood workforce with an emphasis on teachers' well-being.

Meghan Welch, PhD, is a program specialist at the Georgia Department of Education. She received her doctoral degree in early childhood and elementary education from Georgia State University where she also held a postdoctoral fellow position on a project funded by the National Science Foundation. Her early education research and writing interests include child development, digital literacies, educational media, and thinking about all of these from the perspective of a mother – she has four young children.

Evaluating Early Learning in Museums

Planning for our Youngest Visitors

Nicole Cromartie, Kyong-Ah Kwon, and Meghan Welch

Routledge
Taylor & Francis Group

LONDON AND NEW YORK

First published 2021
by Routledge
2 Park Square, Milton Park, Abingdon, Oxon OX14 4RN

and by Routledge
52 Vanderbilt Avenue, New York, NY 10017

Routledge is an imprint of the Taylor & Francis Group, an informa business

© 2021 Nicole Cromartie, Kyong-Ah Kwon, Meghan Welch

British Library Cataloguing-in-Publication Data
A catalogue record for this book is available from the British Library

Library of Congress Cataloging-in-Publication Data
A catalog record for this book has been requested

ISBN: 978-0-367-35577-7 (hbk)
ISBN: 978-0-367-76160-8 (pbk)
ISBN: 978-0-429-34041-3 (ebk)

Typeset in Times New Roman
by Apex CoVantage, LLC

Contents

Figures and tables

Figures

Tables

Preface

"Creativity becomes more visible when adults try to be more attentive to the cognitive processes of children than to the results they achieve in various fields of doing and understanding." (Edwards, C., Gandini, L., & Forman, G, 1998) I love this quote from Loris Malaguzzi, the pioneering educator who developed the educational philosophy known as the Reggio Emilia Approach to early childhood education. Malaguzzi invites educators and caregivers to slow down and be present with young children, to appreciate every moment we have together. What better place to slow down together, to be present with one another, and to explore creativity together than a museum?

Museum educators understand the value of specialized programs designed for young children and their caregivers. As practitioners we benefit from the wealth of research and time-honored tradition of family programming in art museums to draw from in our work. Our field is filled with creative and generous colleagues who are happy to share best practices and serve as thinking partners when we begin to develop a new program, or set out to recast an existing program. Yet there are few contemporary, research-based publications one can turn to that are devoted to early learning in museums. *Evaluating Early Learning in Museums: Planning for our Youngest Visitors* addresses this need in our field.

Evaluating Early Learning in Museums tells the story of a special partnership between early childhood education researchers, Dr. Kyong-Ah Kwon and Dr. Meghan Welch, and museum educator Nicole Cromartie. In 2015, the research and writing team came together to study one of the High Museum of Art's most popular and enduring early learning programs, Toddler Thursday, with the initial goal of assessing impact and gathering insights to improve the quality of this program. What began as a small-scale evaluation study grew into a fruitful partnership, with ripple effects that can still be felt within the High's education work. The data and key insights brought forth by the study inspired the High's team and reinvigorated our

viii *Preface*

commitment to early learners in the museum. Indeed, the Toddler Thursday evaluation study fundamentally changed the High's approach to serving young visitors and their caregivers, yielding effects that can be felt across the Museum today.

Practitioners across the globe understand the importance of promoting children's development and learning in the museum context. *Evaluating Early Learning in Museums* highlights a range of incredibly inspiring programs through interviews with museum educators in select museums whose work exemplifies developmentally appropriate and culturally relevant practice. Delving into early learning evaluation in an international context provides a diverse body of models for consideration and a wealth of data to mine when planning programs serving early learners and their caregivers in your museum.

Like you, I am always eager to learn more about effective museum education programs and keen to hear stories about new initiatives, experiments, and innovations that bring our work closer to meeting the evolving needs of museum audiences. I am eternally on the lookout for articles and books that will spark a new idea, shift my thinking around an established approach, or help me put pedagogy into practice. Publications grounded in solid research hold a special place on my bookshelves and find themselves marked up and quoted often. It is my hope that *Evaluating Early Learning in Museums* becomes a trusted resource and practical guide to planning for early learners in museums for you. I have no doubt I will return to this book often.

Virginia Shearer
Eleanor McDonald Storza Director of Education, High Museum of Art

References

Edwards, C., Gandini, L., & Forman, G. (Eds.). (1998). *The Hundred Languages of Children: The Reggio Emilia Approach-Advanced Reflections* (Second Edition). London, England & Greenwich, CT: Ablex Publishing Corporation.

Acknowledgments

There are so many individuals who support family programming at the High Museum. The art partners and co-visioners for family engagement on the Woodruff Arts Center campus are a truly inspiring group of educators: Virginia Shearer from the High Museum, Chris Moses and Olivia Aston-Bosworth at the Alliance Theatre, and Ruthie Miltenberger at the Atlanta Symphony Orchestra. Thank you to the family programs administrators and instructors at the time of the evaluation and current staff who continuously work to ensure that the Museum is doing its best to serve families with young children: Deirdra Alexander, Grace Diepenbrock, Erin Dougherty, Melissa Katzin, Nicole Livieratos, and Melissa Word.

Thank you to the community members and partners who helped to improve the quality of our programming, particularly Georgia State University and the full research team which included: Kyong-Ah Kwon (Principal Investigator), Meghan Welch (Co-Principal Investigator), Melody Milbrandt (Research Consultant), Stacey French-Lee (Consultant), Rukia Rogers (Consultant), and Dedra Davison (Business Manager). Other influential community partners include "Mr. Ken the Librarian" Vesey, Kimberly Gregory, Elizabeth Labbe-Webb, and Kimberly Ross.

Much gratitude goes to the support staff at the High Museum of Art. Thank you to the security and visitor services teams for treating families with young children with the respect they deserve. Kristen Summerall plays a huge role in ensuring that the Museum is a welcoming space for ALL visitors. Every toddler looks forward to seeing the Security Officer lovingly referred to as "Ms. Sandy" each week and sharing their artwork with her.

Thank you to Heidi Lowther for encouraging the writing of this book. Gratitude for the many individuals who helped with the writing, reading, and editing of this book: Olivia Aston Bosworth, Stephanie Bynum, Nichols Clark, Ben Coleman, Judy Cromartie, Denver Evaluation Network, and Laureen Trainor in particular, Katie Domurat, Ariel Gory, Kangan Gupta, Natalie Haigh, Regina Jankowski, Melissa Katzin, Shantras Lakes, Nicole

Livieratos, Heather Medlock, Amanda Palmer, Sam Provenzano, Sharon Shaffer, Melissa Smith, Courtney Waring, and Ken Vesey.

We are indebted to the young children in our own personal lives, who have enriched our professional practices.

For Nicole: A visit to the Cummer Museum of Art & Gardens in Jacksonville, Florida with my then 6-month-old niece, Parker Bloomston, opened my eyes to what is possible with babies in museums. My godson Mateo Jimenez was a test subject for many art activities and remains a continuous source of inspiration. Thank you P for setting me on a new path and to Mateo for making me a better educator. I am grateful to my husband Ben who shares my passion for art and young children and who is my number one champion.

For Kyong-Ah: I am grateful for my family who were willing to drive 12 hours from Oklahoma to Atlanta for two follow-up visits and their support throughout this journey. This whole process has reinforced my love of art and artists.

For Meghan: I am the happiest in places where children are learning. I learned so much during this project. Thank you for the support of my husband, Eric, and children – I'm fortunate to learn from young minds at home and work.

Most of all, a sincere thank you to all of the families who have been brave enough to take their very young children to museums.

Introduction

Early learning and family visits in the context of the museum

Art museums' impeccable white walls, carefully arranged collections of invaluable works of art, paintings displayed at adult eye level, quietly strolling visitors, the presence of security guards, signage about museum etiquette: all unconsciously, but clearly, communicate that this is not a "kids zone." In fact, art museums are some of the most reluctant types of museums to welcome and embrace young visitors (Mallos, 2012) although children are naturally and spontaneously attracted to artwork – to its diverse configurations of color, shape, and scale. However, when intentionally designed as inviting and welcoming spaces, museums are magically transformed into fun and creative learning environments for even the youngest children. Children enthusiastically adventure through these new spaces, connecting to and reinterpreting the artwork, and sharing their unique ideas and perspectives.

In recent years, there has been a remarkable increase in the quantity and variety of programs offered for young children in both traditional museums and children-targeted museums (Munley, 2012). For example, in the United States, approximately 80% of museums are known to provide educational programs for children (Bowers, 2012) and spend more than $2 billion annually on educational activities in these contexts (American Alliance of Museums, 2009). This is an exciting development. The ingenuity and success of these museums in attracting children and families, and engaging them in innovative discovery experiences is evident. A question still remains – how can we co-create the opportunity and the environment to maximize enjoyment and learning for children (the very youngest in particular) and their families, in art museums and other similar settings? Hopefully, this book provides some insight.

One of the key prerequisites to building the ideal learning space in art museums is to understand children's development – to learn how to see things through their eyes. The museum's environment and programs should be finely tuned to children's interests and needs, and to supporting their developmental potential. This is often considered parallel to

Developmentally Appropriate Practices (DAP, National Association for the Education of Young Children, 2009), grounded in developmental and educational theory and research, and what is known about effective individualized and culturally responsive early childhood programs. This book is built on this theoretical and practical foundation.

A number of developmental theories (e.g., Piaget and Vygotsky's theory of cognitive development, Bandura's social learning theory, attachment theory, dynamic systems theory, bio-ecological theory, and brain research) and research publications have demonstrated that, while children develop at different rates, the first five years are crucial in children's rapid brain, physical, social emotional, language, and cognitive development (Center on the Developing Child, 2007; Shonkoff & Phillips, 2000). In particular, toddlerhood (the focus of the central case study in this book) is generally considered a critical developmental period not only for children but also for their caregivers, given a toddler's unique developmental changes and needs (Horm, Norris, Perry, Chazan-Cohen, & Halle, 2016; Kwon & Elicker, 2012; McHale, Kuersten-Hogan, Laurett, & Rasmussen, 2000; Smith, Calkins, Keane, Anastopoulos, & Shelton, 2004). Toddlers are often referred to as the "Terrific Twos," bringing exhilarating joy and laughter to caregivers. At the same time, they are infamously dubbed the "Terrible Twos," as they place distinctive demands and challenges on caregivers while expressing unique developmental needs, such as the emergence of independence, willfulness, non-compliance, verbal skills, and symbolic representation (Core, Hoff, Rumichie, & Senor, 2013; Kwon, Han, Bingham, & Jeon, 2012). For example, according to attachment theory and research, with independent walking, toddlers emerge from a total reliance on their caregivers and begin to explore, negotiate, and restructure the relationship between two worlds – the world inside and the world outside – or between two basic human motivations: attachment and learning through active exploration of the environment (Ainsworth, Blehar, Waters, & Wall, 1978; Bowlby, 1988; Liberman, 2017). Thus, it is crucial to understand young children's learning and development and their unique ways of exploring and interacting with the environment.

Many researchers cite that the experiences young children have in early years, especially through various types of play (e.g., symbolic, functional, social play) and sensory experiences, shape their brain structures and lay an important foundation for learning and development (Center on the Developing Child, 2010). Young children are sensory, kinetic, and messy learners. They learn best through active play, movement, hands-on, and sensory experiences. Research consistently demonstrates strong links between positive, playful experiences and the extent of a child's linguistic, physical, cognitive, social, and creative development (Kwon, Bingham, Lewsader, Jeon, & Elicker, 2013), which highlight the importance of early play experiences.

In many settings, such as the home and educational environments, toddlers actively participate and explore. With adult guidance they negotiate a mutually agreeable balance between the safety of closeness and acceptance and the excitement of free exploration. As such, informal learning settings like museums can provide extraordinary opportunities to support toddlers' emerging needs and learning through various sensory inputs, free exploration, and play in partnership with caring adults (Clarkin-Phillips, Carr, & Paki, 2012; Terreni, 2015). Toddlers in particular need a variety of sensory, verbal learning experiences, with opportunities for many repetitions, if they are to build healthy learning pathways in their brain. During the active processes of viewing and creating art, toddlers can discover their identities as independent beings, and the wonders of free exploration, bold expression, and experimentation with a variety of media and materials.

They might face challenges, burst into tears, and stomp their feet out of frustration, but it is also possible that during artistic expression, toddlers will self-regulate, and exercise their independence within set limits. Young children use visuals to communicate with and about the world (Bamford, 2003), display interest in, and extensive knowledge of, simple literacy elements such as color, shape, and line, and can learn high levels of vocabularies through exploration of various media and adult guidance (Lopatovska, Hatoum, Waterstraut, Novak, & Sheer, 2016).

Museums open the door for great opportunities to explore diversity in children's learning experiences (Tenenbaum & Callanan, 2008). As community resources, museums are positioned to provide an inclusive and welcoming environment for families of all backgrounds and cultures (Callanan et al., 2020). As children view and explore various cultural artifacts in the museum, they build better social understandings about who they are and how they fit in the community (Goble, Wright, & Parton, 2015). This experience may extend their understanding of other people and different perspectives, through observing and interacting with people from diverse demographic and cultural backgrounds. Increasingly, research points to family visits (rather than visits with a school or other community-based group) being a determining factor for whether a child will return to museums in adulthood. According to a study by Impacts Experience, over 60% of adult visitors in the United States first attended museums as children. Their data also indicates that children who visited museums with their families feel more welcome in museums than children who visited with school or community groups (Dilenschnieder, 2019). With a few exceptions, this book focuses on these critical family visits to museums.

During the museum visit, the supporting role adults play in children's artistic learning is critical (Terreni, 2017). Once children experience a sense

of understanding, motivation, and enjoyment in viewing and/or expressing their ideas about artwork, they are ready to learn and extend their conversation about visual arts concepts (Weier, 2004). Adults can provide prompts to introduce children to the language and concepts around visual arts. Experts suggest that adults talk about color, line, shape, texture, and material to use the artwork as "a trigger for discovery" (McKenzie, 2001). Adults can actively encourage children to brainstorm, develop hypotheses, create stories, build meaning, and make connections to their prior knowledge or experiences (Weier, 2004). Research shows that although many caregivers value art and museum visits as important, and perceive such experiences as positive and encouraging, many others hesitate to visit museums due to a number of perceived barriers (e.g., unfamiliarity with the setting, perception of children being too young to benefit from the visit, Bowell, 2012; Hipkis, 2009; Swan & Manjarrez, 2013; Terreni, 2017). There is limited information available about how museums create learning opportunities for early learners and facilitate their museum visits. Empirical research regarding the experiences of very young children and families during art museum visits, and practical suggestions as to how the museum can help maximize their learning, are even scarcer.

Evaluating Early Learning in Museums: Planning for Our Youngest Visitors contributes toward filling this gap by focusing on the case study of an evaluation of a toddler program at an art museum in the American South. This text will begin with an introduction to other contemporary early learning program models across the globe. Following a chapter dedicated to providing context about the High Museum of Art and its family offerings, the book will delve into the evaluation design and study. Chapter 4 will align the researchers' recommendations with the museum educators' responses, and in this dialogue, the efforts to increase accessibility for families and strengthen the quality of programming through evaluation research will become clear. Lastly, *Evaluating Early Learning* will consider how to facilitate museum visits to maximize young children's enjoyment and learning in developmentally appropriate ways, by integrating the findings of evaluation research and the up-to-date literature and wisdom from experts in museum education across different countries and cultural contexts (e.g., Bongiorno, 2014; Danko-McGhee, 2016; Duckett, Main, & Kelly, 2011; Kaufman et al., 2014; MacRae, 2007; Mahoney, 2015; Terreni, 2017).

The pages ahead document the journeys of the authors of this book: one museum educator and two researchers, dedicated to improving experiences for families with young children at the High Museum of Art. The shared aim is to create a research-based practical guide for museum educators who are developing or strengthening existing family programs through specialized offerings for families with young children.

References

Ainsworth, M. D. S., Blehar, M. C., Waters, E., & Wall, S. (1978). *Patterns of Attachment: A Psychological Study of the Strange Situation*. Oxford, England: Lawrence Erlbaum.

American Alliance of Museums. (2009). *Museum Financial Information Survey*. www.aam-us.org

Andre, L., Durksen, T., & Volman, M. L. (2017). Museums as avenues of learning for children: A decade of research. *Learning Environments Research*, 20, 47–76.

Bamford, A. (2003). *The Visual Literacy White Paper*. Australia: A Report Commissioned for Adobe Systems Pty Ltd.

Bongiorno, L. (2014). How process-focused art experiences support preschoolers. *Teaching Young Children*, 7(3). Washington, DC: National Association for Education of Young Children.

Bowell, B. (2012). *Research Report: Community Engagement Enhances Confidence in Teaching Visual Art*. Wellington, New Zealand: Ako Aotearoa. http://akoaotearoa.ac.nz/download/ng/file/group-3592/community-engagement-enhances-confidence-inteaching-visual-art.pdf

Bowers, B. (2012). A look at early childhood programming in museums. *Journal of Museum Education*, 37(1), 39–48.

Bowlby, J. (1988). *A Secure Base: Parent-Child Attachment and Healthy Human Development*. New York: Basic Books.

Callanan, M. A., Legare, C. H., Sobel, D. M., Jaeger, G. J., Letourneau, S., McHugh, S. R., & Willard, A., et al. (2020). Exploration, explanation, and parent-child interaction in museums. *Monographs of the Society for Research in Child Development*, 85(1). doi: 10.1111/mono.12412

Center on the Developing Child at Harvard University. (2010). *The Foundations of Lifelong Health Are Built in Early Childhood*. www.developingchild.harvard.edu

Clarkin-Phillips, J., Carr, M., & Paki, V. (2012). *Our Place: Being Curious at Te Papa*. Wellington, New Zealand: Teaching and Learning Research Initiative. www.tlri.org.nz/tlriresearch/research-completed/ece-sector/our-place-being-curiouste-papa

Core, C., Hoff, E., Rumiche, R., & Senor, M. (2013). Total and conceptual vocabulary in Spanish-English bilinguals from 22 to 30 months: Implications for assessment. *Journal of Speech, Language, Hearing Research*, 56, 1637–1649. doi: 10.1044/1092–4388 (2013/11–0044)

Danko-McGhee, K. (2016). First encounters: Early art experiences and literacy development for infants. *International Art in Early Childhood Research Journal*, 5, 1–12.

Dilenschnieder, C. (2019). *School Groups vs. Family Visitors: Which Kids Come Back as Adults?* www.colleendilen.com/2019/09/04/school-group-vs-family-visitors-which-kids-come-back-as-adults-data

Duckett, S., Main, S., & Kelly, L. (2011). Consulting young children: Experiences from a museum. *Visitor Studies*, 14(1), 13–33.

Goble, C. B., Wright, S., & Parton, D. (2015). Museum babies; linking families, culture, and community. *YC Young Children*, 70(3), 40–48.

Hipkis, R. (2009). *Inquiry Learning and Key Competencies: Perfect Match or Problematic Partners?* http://nzcurriculum.tki.org.nz/Curriculum-stories/Keynotes-and-presentations/Inquiry-learning-and-key-competencies.-Perfect-match-or-problematic-partners

Horm, D., Norris, D., Perry, D., Chazan-Cohen, R., & Halle, T. (2016). *Developmental Foundations of School Readiness for Infants and Toddlers, A Research to Practice Report*, OPRE Report # 2016–07. Washington, DC: Office of Planning, Research and Evaluation, Administration for Children and Families, U.S. Department of Health and Human Services.

Kaufman, R., Rinehardt, E., Hine, H., Wilkinson, B., Tush, P., Mead, B., & Fernandez, F. (2014). The effects of a museum art program on the self-concept of children. *Journal of the American Art Therapy Association*, 31, 118–125.

Kwon, K., Bingham, G. E., Lewsader, G., Jeon, H., & Elicker, J. (2013). Structured task versus free play: The influence of social context on parenting quality, toddlers' engagement with parents and play behaviors, and parent-toddler language use. *Child and Youth Care Forum*, 42, 207–224.

Kwon, K., & Elicker, J. (2012). The role of mothers' and fathers' parental control and coparenting in toddlers' compliance. *Early Education & Development*, 23, 748–765.

Kwon, K., Han, S., Jeon, H., & Bingham, G. E. (2012). Mothers' and fathers' parenting challenges, strategies, and resources in toddlerhood. *Early Childhood Development and Care*, 183, 415–429.

Lieberman, A. (2017). *The Emotional Life of the Toddler*. New York: Free Press.

Lopatovska, I., Hatoum, S., Waterstraut, S., Novak, L., & Sheer, S. (2016, accepted). Not just a pretty picture: Visual literacy education through art for young children. *Journal of Documentation*, 72(6).

MacRae, C. (2007). Using sense to make sense of art: Young children in art galleries. *Early Years*, 27, 159–170.

Mahoney, K. (2015). *Engaging Young Children in the Art Museum: An Educational Criticism of an Art Museum Summer Class*. Electronic Theses and Dissertations. 391.

Mallos, M. (2012). Collaboration is the key. *Journal of Museum Education*, 37(1), 69–80.

McHale, J. P., Kuersten-Hogan, R., Lauretti, A., & Rasmussen, J. L. (2000). Parental reports of coparenting and observed coparenting behavior during the toddler period. *Journal of Family Psychology*, 14, 220–236.

McKenzie, B. (2001). Working with Schools on the Problems of Looking, *Engage*, 8, 22-26.

Munley, M. E. (2012). *Early Learning in Museums. A Review of Literature*. Washington DC: Smithsonian Institution's Early Learning Collaborative Network & Smithsonian Early Enrichment Center.

National Association for the Education of Young Children (2020). Developmentally Appropriate Practice: Position Statement. https://www.naeyc.org/sites/default/files/globally-shared/downloads/PDFs/resources/position-statements/dap-statement_0.pdf

Shonkoff, J. P., & Phillips, D. A. (Eds.). (2000). *From neurons to neighborhoods: The science of early childhood development.* National Academy Press.

Smith, C.L., Calkins, S.D., Keane, S.P., Anastopoulos, A.D., & Shelton, T.L. (2004). Predicting stability and change in toddler behavior problems: Contributions of maternal behavior and child gender. *Developmental Psychology, 40*(1), 29–42.

Swan, D. W., & Manjarrez, C. A. (2013). *Children's Visitation to Libraries and Museums: Research Brief Series, No. 1* (IMLS2013-RB-01). Washington, DC: Institute of Museum and Library Services.

Tenenbaum, H., & Callanan, M. (2008). Parents' science talk to their children in Mexican-descent families residing in the USA. *International Journal of Behavioral Development, 32,* 1–12. https://doi.org/10.1177/0165025407084046

Terreni, L. (2015). Young children's learning in art museums: A review of New Zealand and international literature. *European Early Childhood Education Research Journal, 23*(5), 720–742.

Terreni, L. (2017). Beyond the gates: Examining the issues facing early childhood teachers when they visit art museums and galleries with young children in New Zealand. *Australasian Journal of Early Childhood, 42,* 14–21.

Weier, K. (2004). Empowering young children in art museums: Letting them take the lead. *Contemporary Issues in Early Childhood, 5*(1), 106–116. doi: 10.2304/ciec.2004.5.1.2

1 Young children in museums today

Recent program models for the High Museum of Art

A growing audience

A wealth of research and a growing understanding of the development of young minds has fed a burgeoning interest in programming for this increasingly important audience. By following the recent journey undertaken by staff at the High Museum in establishing new programs and initiatives for early learners, this chapter will detail some established and emerging trends that served as models, including:

- programming for infants
- gallery tours for early learners
- early learning programs in modern and contemporary art museums
- how museums are thinking more holistically about young children in offering amenities and other resources

The infancy of a thoughtful plan at the High Museum

Since its founding, the High Museum of Art has positioned education at the core of its mission. Teaching art and creating a dedicated space for children have always been priorities of the Museum. The High received its first home in 1926, and by 1928 the new High Museum had welcomed 16,000 visitors, formalized art classes, and had opened a special children's section (Atlanta Historical Society, 1994, p. 31). In 1968, the Museum was joined by the Alliance Theatre (then the Alliance Resident Theatre Company) and the Atlanta Symphony Orchestra to form the Woodruff Arts Center in Midtown Atlanta, Georgia.

In 2015, the Museum established the goal to transform Atlanta into a city where exposure to fine arts at an early age is a hallmark of growing up in the Capital of the South. This goal translated into several new family initiatives, a deeper focus on accessibility and inclusion, and several community-based

partnerships. These initiatives provided an opportunity to rethink existing methods when designing for family visitors alongside experts in the field. All programs were developed with the aim of creating educational experiences that bring families together, are developmentally appropriate, and incorporate strategies for both looking at and making open-ended, creative, and playful art. Additionally, the goal of inclusion centered the necessity of having program participation that reflected the diverse population of the city of Atlanta. In particular, as a majority African American and linguistically diverse city in the American South, the focus on inclusivity in program design and communications became one of major importance. High Museum staff knew that families with young children made up a large proportion of family audiences at the Museum, and it was decided early on that the Museum's youngest visitors (from birth – 8 years old) would be a major focus of planning.

With the launch of a new family initiative, the education team kicked off this new chapter for the Museum with a reflection on the history and theory of early learning in museums and the state of the field at the time. Sharon Shaffer's *Engaging Young Children in Museums*, originally published in 2014, was the perfect primer. In it, Shaffer expertly outlines the history of children in American museums from the founding of the Brooklyn Children's Museum in 1899, through the development of special children's exhibitions at The Toledo Museum of Art in 1914, to children's story times at The Metropolitan Museum of Art in 1918 (Shaffer, 2015). *Engaging Young Children in Museums* is an essential text for museum professionals working with family audiences to understand how we arrived where we are today with programming for young children in museums. Thanks to the efforts of trailblazers like Sharon Shaffer and many other museum educators, museums of all types have recognized that young children are a critical audience and there are many model programs and initiatives for museum professionals to learn from.

When one works in museum education, it can be relatively straightforward to survey what colleagues in the field are up to. If your museum is contemplating a new initiative, a quick internet search will reveal similar programs in other museums that might be used as models for development within your institution. High Museum education staff continuously research best practices for perennial activities in museum education (art making and story time being common examples) but were also interested in more novel ways in which early learners were being considered in museum spaces. The following program examples represent a variety of approaches to early childhood education utilized by museums worldwide at the time of writing this book. This multitude of perspectives underscores Sharon Shaffer's assertion in *International Thinking on Children in Museums: A*

Sociocultural View of Practice, that it is "not possible to identify a singular approach to education" (Shaffer, 2020).

Infant programs

High Museum educators observed the growth of early learning programs in museums, over the past decade in particular, expanding from preschool visits to include infant programming for families. Since the 1990s, the High Museum has presented programs designed for families with toddlers (approximately 12–36 months old). With the new family initiative, High Museum staff started to think more deeply about the many younger siblings (infants from birth up to 12 months old) who participate in Toddler Thursdays and in other family programming at the Museum. On Toddler Thursdays and on family days, there were a significant number of infants present.

Many museums are creating programs for families with infants, with contrasting approaches. For example, The National Museum of African American History and Culture in Washington, DC, offers a close looking program for infants and their adults called Cultural Cuddles. Activities for babies change each month and include discovery-based themes, including "faces," "my senses," and "color" (National Museum of African American History and Culture). In contrast, "Baby Mindful" at Orleans House Gallery in London is designed to support the adult mental health of caregivers of pre-crawling babies (Orleans House Gallery, 2018). Seeing divergent program models like these, High Museum staff began to wonder what approach to take to best serve this audience at our institution.

While at a local conference on early learning and literacy, High staff were introduced to the concept of *joint attention* and the work of Michael Tomasello (who had once served as a professor at Emory University in Atlanta, Georgia). Joint attention, a child-directed shared looking experience with an adult that benefits early language acquisition, seemed to High Museum education staff to be ideally suited for the museum context (Tomasello, 1986). Museum experiences are centered around looking at art together and sharing perspectives with our companions. This concept also resonated on a personal level with several education staff members who had experienced transformative moments with babies in museums. The powerful connection between language development and shared experience of the visual world led High Museum education staff to *Talk With Me Baby*.

Talk With Me Baby is an Atlanta-based cross-organizational initiative, designed to support quality conversations between children and their caregivers during the first three years of life. This initiative is led by the Georgia Department of Public Health and Department of Education, Emory

University's School of Nursing and Department of Pediatrics, the Marcus Autism Center at Children's Healthcare of Atlanta, the Atlanta Speech School's Rollins Center for Language and Literacy, and Get Georgia Reading – Georgia's Campaign for Grade Level Reading. The premise of Talk With Me Baby is to educate the public about the critical importance of language nutrition – the quantity and quality of nourishing language – in children's most dramatic time of development: before 3 years of age (www.talkwithmebaby.org). The mission and theory underpinning Talk With Me Baby seemed to be in alignment with the concept of joint attention, and immediately identified the initiative as an intriguing potential partner for the High Museum.

High education staff began conversations with Kimberly Ross, Senior Manager, Early Brain Development and Language Acquisition at the Georgia Department of Public Health regarding the potential development of a new infant program following the principles of the Talk With Me Baby program. Ross confirmed High Museum staff's intimations that art museums might be the perfect place to start conversations with babies, and to introduce new words that families wouldn't typically use in the home. These conversations evolved into a partnership between Talk With Me Baby and the High Museum of Art, and the co-development of a High Museum program designed for caregivers with infants from birth through 14 months of age. Ross consulted with the Museum, providing both classroom and in-gallery trainings for staff as well as guiding program design and scripting. During the first conversation between High Museum education staff and Talk With Me Baby, Kimberly Ross immediately saw the opportunity of an infant program inside a museum. "One of the best things that families and educators can do to support healthy brain growth," she explained over a phone call, "is to introduce lots of words." The Talk With Me Baby website features a section dedicated to "conversation starters": a list of phrases that caregivers might use in different locations like the beach, shopping, or at bedtime, many of which are easily adapted for a museum visit (Start a Conversation). Museums represent a location and source of activities where new vocabulary that babies wouldn't necessarily hear around the home can be introduced.

What resulted from this collaboration was Baby Book Club, a monthly 20-minute session, where a High Museum teaching artist pairs an infant book with a work of art in the galleries, to get adults and their babies talking. For the pilot program on Saturday, January 5, 2019 at 11:15 a.m., teaching artist Nicole Livieratos led 18 participants in activities related to *Winter Landscape* painting by Alex Katz and *A Snowy Day* by Ezra Jack Keats. Nicole greeted families, introduced the Talk With Me Baby initiative, and outlined the experience participants would share in the gallery together. She

read *A Snowy Day* in front of Alex Katz's *Winter Landscape* and encouraged close looking and conversation about the artworks in the gallery. Several families had their babies make snow angels on the rug. At the end of the program, she distributed Talk With Me Baby books (offered in both English and Spanish), which were received with appreciation by families. Participants lingered long after the program, socializing with other families and providing feedback about the program. When asked how they heard about Baby Book Club, the first family who arrived responded that they had found the program listed in an internet search for things to do with babies in Atlanta. They detailed their frustration surrounding the lack of things to do with this age group in the city, and expressed appreciation for the High's new program meeting their needs. Given this response, it is perhaps unsurprising that Baby Book Club remains an ongoing and popular program among the High's offerings, and continues to evolve to meet the needs of caregivers and their babies.

Tours for early learners

Museum tours are typically led by museum staff or volunteer docents and consist of guided visits to a handful of artworks on display to share information and spark discussion among participants. Tours are a well-established means for museums to connect audiences with what is currently on view. Like so many other museums worldwide, the High Museum has long offered gallery tours designed for adults and for families with children ages 5 and up, leading curious education staff to speculate as to what a tour for visitors younger than the age of 5 might look like. This interest launched early experiments in tours for early learners in 2014, in preparation for an exhibition entitled, *Habsburg Splendor: Masterpieces from Vienna's Imperial Collections* (on view October 2015 – January 2016). High Museum Interpretation staff were inspired by the *Gala Carriage of the Vienna Court – The "Princes' Carriage"* ca. 1750–1755 from the collection of Kunsthistorisches Museum, Vienna, which would be on display for the exhibition. This opulent carriage made of wood panels, bronze, glass, iron, velvet, silk, and gold embroidery was designed to carry the imperial family's children: a striking example of an 18th-century stroller. Noticing an increase of families with children in 21st-century strollers in High Museum galleries, the interpretation team took a stab at designing a stroller tour specifically for the *Habsburg Splendor* exhibition. For this project, educators conducted research, looking at examples set by other institutions. Through this process of research, staff quickly learned that there were many different models for stroller tours being offered in museums at

the time and that they would need to decide which best aligned with High Museum educational philosophy, and the identified goals for their tour.

Each tour differed from institution to institution in terms of duration, frequency of the offering, and content, but the major distinction between all of the tour models researched was whether they were designed specifically for the adult caregiver, or for the entire family, with the infant and developmental appropriateness in mind. Museum website program descriptions often explicitly state who the tour is designed for. Stroller Tours at the Whitney Museum of American Art were clearly focused on the adult experience; "Whitney Teaching Fellows – PhD candidates in art history – lead engaging tours of current exhibitions before the Museum opens to the public, for adults with babies who are 0–18 months old" (Whitney Museum website, Stroller Tours). In contrast, other early learning tour descriptions would detail a tour clearly designed for the little one in the party. For example, the Brooklyn Museum's Stroller Tours description is all about the baby: "We welcome our youngest museumgoers and their caregivers to experience the Museum through an interactive tour. This baby-friendly program features touchable objects, songs, exploration of the art in our galleries, and an opportunity to connect with other adults" (Brooklyn Museum website, Stroller Tours). High education staff came to understand they would have to make a decision to one side of this defining line.

Being in conversation with museum educators who were responsible for designing their museum's early learner tours reveals the thinking behind the development of their programs, who they designed the experience for, and why.

Tours designed for adult caregivers of young children:
Art Gallery of Ontario, strolling in the galleries

Melissa Smith is Assistant Curator, Community Programs in the department of Public Programming & Learning at the Art Gallery of Ontario (AGO). She was responsible for developing their Strolling in the Galleries program in 2018. The online description of this program takes the form of a playful invitation: "Come explore our greatest hits with your little one! These relaxed 1 hour tours allow for grown-up discussions, free of pressure, where no one minds a coo or a cry. Designed to feed your creativity, while engaging your little ones with colours and shapes that will enhance visual literacy in developing brains" (Art Gallery of Ontario, 2018). Melissa shared some background on how this program came to be and why she chose to focus the program design on adults.

Strolling in the Galleries is a relaxed tour for parents to have con-
versations and talk about art while an art educator gives them tips
about how they might start to talk about art with their little one, when
they are ready. Crying babies are present, but everyone is OK with it.
Strolling in the Galleries is offered twice on the first Tuesday of every
month and the program consistently reaches capacity (approximately
20 participants per tour). The anecdotal feedback that we received
from participants was that it was the drive to connect with other par-
ents that brought them to the program, and the acknowledgement that
we would provide a familiarization tour of the building from the per-
spective of a parent (spaces to feed, quiet places, washroom locations,
where you can store your stroller, etc.). Part of the familiarization
tour includes pointing out facilities that their babies would eventually
transition to at AGO, including a hands-on center for little ones, and
a library nook where we call out books that are about aesthetics for
early learning, so we also demonstrate that we have informational
resources for their use. Part of the tour was built on the premise of
encouraging adult conversation, with space for noise and babies,
and the other goal was to get people feeling more comfortable in the
building, to facilitate future self-guided visits, and in the hopes that
participants would connect with someone in the program and might
decide to come back together at another time.

The reason we landed on creating this tour for adults was because I
was the one designing the program and I do adult and community pro-
gramming. I don't have children, I don't have a background in serv-
ing children, so for me, it was about focusing on parents and getting
parents connected with other new parents from the community per-
spective. This is a practitioner's perspective: you do what you know.
In an ideal world, I would have done more research, I would have
connected with community, but in this instance, it was also based on
a lot of my friends being new parents, and talking about how isolated
they felt during their parental leave – so that's what felt right to me:
adults connecting while we show them how they can use the gallery
as a tool. In Canada we have paid parental leave for up to a year with
the option to extend, which means more parents take leave. Since that
support system is a part of our governance as a province, there are
many people who form groups because there are more people taking
that time and looking for community. It is a privilege to have paid
leave, but it can also be very isolating. What we were finding is that
entire parental groups would come to the program as opposed to

a single person who is opting in for the experience, so we'd have 20 people show up together because they are a part of this group.

This program is rooted in my approach to all of my programming, from the perspective of wellbeing. Based on the studies of Helen Chatterjee and Guy Nobel we know that museums can be a social determinant of health (Chatterjee & Nobel, 2013), so how do we let people know that coming to a museum doesn't mean you have to be equipped with art historical knowledge or for it to be a place to gain art historical knowledge, it's just about being present in the space. To me, it was always about producing something where there were conversational elements, a dialogical practice, multiple perspectives, and connection.

**– Melissa Smith, Assistant Curator,
Community Programs, Art Gallery of Ontario**

(personal communication between Nicole Cromartie and Melissa Smith, July 17, 2020)

This program is all about getting caregivers comfortable in the museum for themselves and their community of fellow parents, but it also very intentionally sets up what is next for their children in the museum. Unlike the United States, Canada (and the world's other 40 richest countries) offers parents paid parental leave (Chzhen, Gromada, & Rees, 2019). Since this is provided by the government for all residents, and not on an individual basis by employers (who in the US can choose whether or not to offer leave, and often choose not to), there are many more parents who are able to take advantage of museum program opportunities like Strolling in the Galleries. Smith accounts for this in planning for the program including scheduling and accommodating larger groups.

*Tours designed for young children and their adults:
baby tour and art crawls at the Toledo Museum of Art*

Regina Jankowski is Family Center Manager at the Toledo Museum of Art in Ohio. Regina has a background in early childhood education and in art education and over 20 years of experience serving children and families. The Toledo Museum of Art offers two different tour experiences for the Museum's youngest visitors and their adults: Baby Tours and Art Crawls. Both experiences are described online using language that unequivocally centers the experience on the child: "Explore the galleries and watch your

child respond to large colorful paintings, then get messy in the studio with baby-friendly art materials" (Toledo Museum of Art website). Here, Regina shares more information about these two tours and why they are primarily designed for the children in attendance.

Since 2013, our volunteer docents have facilitated a free baby tour once per month in the galleries, usually on a Friday evening. The tours meet near the family center; we let families know that they can gather here before or after the tour. The docent leads the families up to the galleries to talk about 1–3 works of art (depending on group size, the docent leading the tour, and the interest level), and then they get a baby book, which features different works of art from the Museum, to take home with them. The tour stops include modeling how to interact with your child in the galleries, discussions on the importance of talking with your babies while they are still pre-verbal, and interactions between the docent and the babies too. Sometimes grown-ups aren't sure and may feel intimidated, especially when it comes to the gallery portion, so it's just about giving them little pointers and talking about the importance of early learning and how that impacts their child throughout their life.

Art Crawls, which we started doing last year, are like a baby tour for children up to 18 months, but also have a studio component. They require registration and are paid. The paid instructor who teaches it has an early childhood, music and art education background and has a following of families who love doing this once per month. The Art Crawl starts with the instructor leading a tour in the galleries looking at artworks that have bright, bold contrasting colors. After some time in the galleries, the families come down to the studio classroom which has been prepped with kraft paper covering the floor and materials laid out – like mini canvases or pieces of paper, with non-toxic, sometimes edible paint. The babies are often in their diapers and things get messy! It's really a fun experience for all. The studio component of this experience is so important because it's multisensory, and the parent is learning as the baby is learning, and having fun. The Art Crawls have been really popular. We started doing them once per month and they would sell out, so we started doing them twice per month. We had regulars who would come every month but their babies have aged out, so we are in the planning and development stages of future programming for a toddler version of the Art Crawl program for children ages 18 months to 3 years old.

Personally, I am all about the holistic approach when it comes to serving families. I am lucky to know Claire Shafer who started the Family Center at the Toledo Museum of Art, who was very integral in early childhood learning here at the Museum. Having that strong foundation here, combined with opening up the Family Center in 1996 and having that accessibility for families to come, opened up a wider perspective on how we do things in the galleries and what we offer. A baby or a toddler is going to get bored very quickly if they are in a carrier or stroller and there's no movement, no interaction, it's just two adults talking to one another, that's not something that is going to be stimulating. Getting close to a work of art and interacting with their grown up is really important. We're privileged to nurture young minds and make the world a better place one tiny step at a time.
*– **Regina Jankowski, Family Center Manager,***
Toledo Museum of Art

(personal communication between Nicole Cromartie and Regina Jankowski, July 31, 2020)

Regina details the Toledo Museum of Art's focus on early childhood education, repeatedly referring back to the importance of early learning and the lifelong impact that these experiences can have on a child. No doubt this is connected to the Museum's strong foundation in early childhood education, as well as Regina's own expertise as a practitioner. Although the two tour examples from the Art Gallery of Ontario and the Toledo Museum of Art are distinct in the primary audiences that they were designed for, they share an important commonality: the practitioners who designed and oversee the tours have an expertise in the audience that the tours serve, and they have rooted the tour experience within this existing area of specialization. The High Museum education team took their own individual and institutional expertise into account, and decided to serve the entire family with a deliberate focus on the young child. Following a study of tour offerings by other institutions and an exhibition-specific tour pilot, the High was ready to contract an expert to help design a tour for the High's ever-growing early learning audience. This tour will be discussed in more depth in Chapter 4.

In modern and contemporary art museums

High Museum educators have found that giving tours of exhibitions which include modern and contemporary art forms like abstraction, installation art, sound, or interactive art to adults can be challenging. In the absence of the

narrative content of representational art, some adult tour participants struggle to find meaning in the work, express concerns that they don't have enough background knowledge to understand the work, or feel that there must be a set of fixed, correct answers to their questions. On the other hand, these same museum educators have had the pleasure of being with young children as they delight in an encounter with more experimental forms of art. Rather than being restricted to a frame, on display beyond the viewpoint of a small child, modern and contemporary art has often burst from the frame into the physical space of young children. This is true for installation and sound art as well as for large abstract paintings that might be hung just three inches above the floor, giving children an unmediated view of color, texture, and other detail.

Museum practitioners have a lot to gain from researchers' insights on aesthetic development and preference in early learners. Katherina Danko-McGhee, and others, have compiled literature reviews on the aesthetic preferences of young children (Danko-McGhee, 2000, pp. 5–13), on aesthetic experiences in early childhood (Mai, & Gibson, 2009), and aesthetic responses of young children to the visual arts (Taunton, 1980), respectively, which have helped inform practitioners who would typically rely on what they've seen in their programs to inform their artwork selections for programs and tours. Danko-McGhee's findings were particularly useful to High staff, as she highlights research that asserts that aesthetic preference among young children cannot be purely based on an understanding of developmental stages, but is also informed by children's culture and individual preference. Several references resonated with education staff, as the findings correlated to their experiences in the gallery, including:

- Danko-McGhee cites the early 1980s research of Martha Taunton that demonstrated a preference for abstract paintings among 4-year-olds. She also points to a 1968 study which concluded that children in kindergarten preferred abstract paintings more than children in grades 4 and up (Danko-McGhee, 2000).
- In contrast, older children, ages 7–10 showed preference for high realism, representational works, with "harmony and clarity" (Danko-McGhee, 2000).
- For children under the age of 4, Danko-McGhee references John French's study from the early 1950s, published as "Children's preferences for pictures of varied complexity and pictorial pattern," which states that very young children "aesthetically respond to pictures that they themselves create, which are abstract in nature" (Danko-McGhee, 2000).

In addition to conducting observations and studying research on aesthetic preferences, High Museum educators also looked to examples of

programming in modern and contemporary art museums to better understand what was possible when working with, and drawing inspiration from, modern and contemporary forms with young children of various ages. Amanda Palmer is the Early Childhood Coordinator at the Museum of Contemporary Art Australia (MCA) in Sydney. Their early learning programs for schools began in 2014 in response to requests from preschool teachers for class visits to the Museum. Around this time, the MCA launched *Art and Wonder: Young Children and Contemporary Art*, a research project between the Museum of Contemporary Art Australia, Macquarie University, and the Mia Mia Child and Family Study Centre, to better understand "young children's engagement, learning and responses to regular encounters with contemporary art in a museum context" (Museum of Contemporary Art Australia, Art and Wonder). Amanda Palmer spoke to what they've learned from working with young children and contemporary artists.

At the MCA, we have seen the effects of our work with young children ripple through not just our creative learning department, but through many different departments at the Museum, which has been really exciting. We learned quickly from young children that introducing them to the artworks alone was not enough. Their questions were often about the artist: "Where are they?" "When will they be coming?" and "Are they making another artwork out the back?" They wanted to know about the person behind the work. So we started to collect photographs of the artists that we knew we were going to be focusing on during our gallery experiences, and then we paired these photographs with an artist's quote as an effective way of sparking storytelling with young children.

We have since extended this practice across all our programs. We began introducing this resource to our school group programs with older children, but it has expanded to become an important part of our broader practice across all areas, including our art and dementia program. Incorporating the artist's voice and photographs of the artist has been really powerful in working with adult audiences too. Over the past couple of years, it has been wonderful to see the early childhood pedagogy and our learnings from young children trickle into the work we do across all age groups.

Contemporary art relates beautifully to young children. At the MCA, we acknowledge that young children are citizens of the present, contributing to and participating in the world in the here and

now. Contemporary art provides us with the unique opportunity to connect with ideas and issues that are currently unfolding within our society and creates a space for the voices of young children and living artists to come together. An important part of the Art & Wonder: Young Children and Contemporary Art research project has been to invite artists from the MCA Collection to meet with the children and share their work with them.

One artist, Maria Fernanda Cardoso, shared in the delight of seeing a group of young children respond to her work for the very first time in 2019. A long soft bench was positioned in the center of the gallery space where Cardoso's work was exhibited – an invitation for visitors to settle-in, observe, and contemplate the artist's large-scale video work. For the young children, however, there was no sitting down on a comfy bench; they were immediately enchanted, moving and twirling to make shadows that entwined with Cardoso's screen projection that stretched from floor to ceiling. Following that joyful, immersive experience, Maria Fernanda sat with us on the gallery floor and generously provided MCA artist educators with the precious opportunity to introduce her as the artist who had made the wonderful work that had so captivated the group. Having this moment to engage with Cardoso alongside her work in the gallery was very special for everyone involved. For us as a group, it was a chance to establish personal connections directly with the artist. For Maria Fernanda and other MCA Collection artists who have also been part of this project in similar ways, these open exchanges with young children may have provided them with an opportunity to glean fresh insights into their practice, through the perspectives of our youngest cultural citizens.

We believe the way young children and contemporary artists see and engage with the world are actually quite similar – they're experimenting with ideas, spaces, materials, and close looking all the time, so I think for us and the Art & Wonder research project, the reciprocity and unique meaning-making that can happen between young children and artists is something that needs to be celebrated and shared – not only within the arts sector but around the world.

– Amanda Palmer, Early Childhood Coordinator,
Museum of Contemporary Art, Australia[*]

(personal communication between Nicole Cromartie and Amanda Palmer, August 2, 2020)

Palmer touches on several important aspects of working with young children in museums. Her first point, that lessons learned while designing for young children can inform and enhance program design for all, is not exclusive to a contemporary art context, and can be of benefit to all museum programmers.

In contrast to the research and first-hand experiences with young children and modern and contemporary art mentioned earlier in this chapter, Palmer's observations were centered not around their aesthetic preferences for contemporary art forms, but rather on children's curiosities about and affinities with contemporary artists, who they relate to as fellow art-makers and observers of the world.

The holistic museum experience

Program design is critical, but is just one part of the overall experience of visiting a museum. In addition to offering special programs and interactive spaces for young families, museums are taking an increasingly comprehensive approach to family visits. Benefits and amenities for families with young children have become a must in museums. This section will cover various offerings in museum settings that welcome and encourage family visitation, including free or reduced admission for children ages 5 and under, welcoming front of house staff, designated stroller parking, free activities to check out, nursing rooms, and others. What are the markers of a contemporary, family-friendly museum?

The High Museum has long aimed to attract families with young children through means beyond, and in addition to, programming. Family memberships, free admission for children age 5 and under, and children's menus in the cafe are just a few of the ways the High aims to be a welcoming space. One of the High Museum's recent and major changes made to better serve families with young children was the creation of a nursing room within the Greene Family Education Center on the lower level of the Museum. Converting an underutilized office space, conveniently located near an accessible bathroom and the toddler workshop, the Museum created a cozy space for families to nurse or bottle-feed their children. Fortunately, the room featured a medium sized window, which offered pleasant natural light for the space. Education staff added curtains, a small couch, wall-mounted changing table, trash can, recliner chair with side table, and a child-sized bookshelf stocked with toddler and infant-appropriate books. Additionally, a lock on the door provides privacy for families in the space. This new feature has received ample praise from users, who often mention that it's not only an ideal space for nursing, but also for taking a break from the stimulating, and sometimes crowded, spaces in the Museum.

The Whitworth Gallery, in Manchester, England, is known for their programs for families with young children, and also has many markers within the museum

to indicate that families are a core audience. The Whitworth boasts a large outdoor area for exploring and programs, free *Art Hamper* rentals, a hands-on studio space, family room, lockers, designated spaces for stroller parking (designated with a simple "Buggy Park" sign under the stairs), and emergency baby supplies (wipes, diapers, and other essentials). Art Hampers (picnic baskets filled with open-ended, recycled art-making materials) are available to check out anytime, encouraging families to create art anywhere in the museum whenever creativity strikes. Within an art museum context, where there are so many things that visitors can't touch, offering free Art Hampers provides children an opportunity to make any visit to the Whitworth sensory and creative.

In 2018, Leeds City Museum was awarded Family Friendly Museum of the Year by Kids in Museums, beating out all other museums in the UK. Natalie Haigh, Learning and Access Officer at the Leeds City Museum, says that the judges awarded this honor in recognition not only of their innovative, year-round programming for families, but also their excellent facilities, warm and welcoming staff, and for "being representative of the different communities in Leeds in its exhibitions." Although the Museum has a designated classroom learning space, Natalie often reserves the Museum's large, central hall and gallery spaces for family programming. Here she explains why she feels that makes Leeds City Museum more family-friendly.

> *Being in the Museum rather than in a separate room means that the families are very visible to all visitors. Programming outside of our classroom also allows us to take up more space and offer a range of different activities. I work with our Youth Engagement Officer, whose remit is teenagers and young people, to try to welcome the family as multigenerational. For example, in the main hall we have had large-scale family days where we would pick a mix of activities so there's something for under fives, under twos, and for older children. We've had things like a DJ school in there for older children, alongside a pom-pom making activity for young children to create and shake to the music. For special exhibitions, we always work to ensure that there is a family-friendly element to each exhibition, unless it's really not appropriate and will be marketed exclusively at adults. Nearly every exhibition has some element of family-friendly interpretation and interaction and a good proportion of our special exhibitions are aimed at families.*
> *— Natalie Haigh, Learning and Access Officer,*
> *Leeds City Museum*

(personal communication between Nicole Cromartie and Natalie Haigh, July 22, 2020)

During this conversation, Haigh also mentioned that the Museum's café offers a children's menu, provides high chairs and includes a play area, with small, colorful picnic tables. Another feature in the café is a "little library" where visitors can borrow or swap books. At the Leeds City Museum, the presence of families (and their value to the institution) can be seen and felt everywhere, from the main hall, through the exhibition spaces, to the café. Though having a designated classroom or family area is a considerable asset for a museum that aims to be family-friendly, it is important that families not feel restricted to these spaces.

Conclusion

As evidenced by the museums highlighted in this chapter, programs for our youngest visitors are moving far beyond the standard art making and story time fare of the recent past. The program models emphasize the importance of building community among adult caregivers, of spending time looking at and talking about art, and the potential to create meaningful, sensory experiences for infants.

While we have come a long way from the era of the museum as an exclusively adult space, we have ample room for continued growth. Museum practitioners continue to face opposition to expanding our reach to young children from colleagues within our organizations, primarily based on misconceptions about childhood and learning. The museums referenced in this chapter have made great strides to place young children at the center of decision making, and in some notable cases have recast them as visible and active contributors to the creative and social lives of their institutions.

Note

* Amanda Palmer at the Museum of Contemporary Art Australia also provided a number of additional resources in which to ground and contextualize her practice and the work of MCA Australia: Britt (2018), Bell, Britt, Langdon, Palmer, & Rusholme (2019), & MCA Australia's Early Learning Manifesto (Museum of Contemporary Art Australia, Early Learning Manifesto), all detailed in the Chapter 1 references.

References

Art Gallery of Ontario. (2018). *Picture Your Family at the AGO.* https://ago.ca/node/32822

Atlanta Historical Society, Inc. (1994). High Museum of Art. *Atlanta History: A Journal of Georgia and the South,* 38(1–2), Spring-Summer. Atlanta: Kenan Research Center.

Bell, D., Britt, C., Langdon, M., Palmer, A., & Rusholme, S. (2019). Early years, art learning, and museums: Principles and practices. *International Art in Early Childhood Research Journal*, 1(1). https://artinearlychildhood.org/wpcontent/uploads/2019/12/ARTEC_2019_Research_Journal_1_Article_7_Bell_Britt_Langdon_Palmer_Rusholme.pdf

Britt, C. (2018). Dancing with Pipilotti: Young children's encounters with contemporary art. *Pedagogy Magazine Issue 04*. https://semannslattery.com/wp-content/uploads/2019/04/dancing-with-pipilotti.pdf?fbclid=IwAR2plBT0mZaLBHxMYK_05Tw5QJB8aVAG4q4-A7D543gT3W8ONYJftMW2imU

Brooklyn Museum. *Stroller Tours*. www.brooklynmuseum.org/education/art_classes/stroller_tours

Chatterjee, H. J., & Noble, G. (2013). *Museums, Health and Wellbeing*. Farnham, UK and Burlington, VT: Ashgate Publishing Ltd.

Chzhen, Y., Gromada, A., & Rees, G. (2019). *Are the World's Richest Countries Family Friendly? Policy in the OECD and EU*. UNICEF Office of Research. www.unicef-irc.org/publications/pdf/Family-Friendly-Policies-Research_UNICEF_%202019.pdf

Danko-McGhee, K. (2000). *The Aesthetic Preferences of Young Children*. New York: The Edwin Mellon Press.

Mai, L., & Gibson, R. (2009). The young child and the masterpiece: A review of the literature on aesthetic experiences in early childhood. *The International Journal of the Arts in Society*, 4(3).

Museum of Contemporary Art Australia. *Art and Wonder: Young Children and Contemporary Art*. www.mca.com.au/learn/early-learning/research-project/

Museum of Contemporary Art Australia. *Early Learning Manifesto*. www.mca.com.au/learn/early-learning/early-learning-manifesto/

National Museum of African American History and Culture. *Early Childhood Education*. https://nmaahc.si.edu/early-childhood-education

Orleans House Gallery. (2018). *You're Never Too Young to Visit Orleans House Gallery*. www.orleanshousegallery.org/news/2018/10/youre-never-too-young-to-visit-orleans-house-gallery

Shaffer, S. E. (2015). *Engaging Young Children in Museums*. New York: Routledge.

Shaffer, S. E. (2020). *International Thinking on Children in Museums: A Sociocultural View of Practice*. New York: Routledge.

Talk with Me Baby. *Start a Conversation*. www.talkwithmebaby.org/start_a_conversation

Talk with Me Baby website. www.talkwithmebaby.org

Taunton, M. (1980). The influence of age on preferences for subject matter, realism, and spatial depth in painting reproductions. *Studies in Art Education*, 21(3), 40–53.

Toledo Museum of Art website. *Art Crawl*. www.toledomuseum.org/visit/events/art-crawl

Tomasello, M., & Farrar, M. J. (1986). Joint attention and early language. *Child Development*, 57(6), 1454–1463.

Whitney Museum of American Art. *Stroller Tours*. https://whitney.org/education/families-stroller-tours

2 Families and the High Museum of Art

The High Museum's education team

The work of the education team at the High is critical for fulfilling the Museum's mission, and engages the public in various ways. A dedicated staff position, Manager of Family Programs, was created in 2015 at the High Museum as well as at partner institutions: The Alliance Theatre and The Atlanta Symphony Orchestra. These positions were created to work as a cohort of thinking partners, to oversee existing family initiatives and programs, to collaborate on campus-wide family events, and to develop new offerings to engage family audiences that had not been previously reached by the Woodruff Arts Center. At the time of the evaluation with Georgia State University researchers documented in Chapter 3, the education department included three focus areas: public programs, interpretation, and school and teacher services. Each of these areas serves families in significant ways: youth programs and family programs fall under the umbrella of public programming at the High. The youth programs team member partners with community organizations like the Atlanta Chapter of Jack and Jill of America, Inc., and facilitates programs for children (roughly ages 4–19) through summer camps, classes, and birthday parties. Interpretation staff create family-friendly interpretative tools for the galleries, including family audio guides, wall text, and family tours. Additionally, interpretation manages the Greene Family Learning Gallery, an interactive space for families. The school and teacher services team designs programs for homeschool groups and develops art exhibitions with local schools, hosting lively openings for the young artists and their families. These combined efforts indicate a commitment to engaging family audiences that cuts across the entire education department. The following sections describe in more detail the existing offerings for family audiences at the High in 2015, immediately prior to the evaluation case study.

Interactive gallery for children and families

The first dedicated space for children in an American art museum opened in 1901 in the Smithsonian's Castle and included real specimens to entice children's interest (Shaffer, 2016). Creating a special place for children's play and exploration has also been a priority of the High Museum since its founding. Just two years after the High opened their doors in 1926, the Museum had formalized their art classes and opened a children's section (*Atlanta History: A Journal of Georgia and the South*, 1994). In October 1968, the High introduced its first dedicated space for families to learn, play, and explore. Though a dedicated space for "children" had been in place for 40 years by this time, the development was significant because it aimed to engage the entire family. This opening coincided with the opening of the Atlanta Memorial Arts Center where the High Museum of Art was housed alongside the Alliance Resident Theatre Company (later renamed the Alliance Theatre company) and the Atlanta Symphony Orchestra (Hale, 2018). This space was volunteer driven, with volunteer mothers at the helm. The 1968 iteration of an interactive space was likely informed by the Museum of Modern Art's (MoMA) Children's Art Carnival, founded in 1942 (personal communication between Nicole Cromartie and Virginia Shearer, February 21, 2020). The Art Carnival (organized by Victor D'Amico, then MoMA director of education) intended to demonstrate techniques for teaching art to children (Museum of Modern Art, 1969). In 1958, a television show broadcast around the world reported on the Children's Creative Center (a version of The Children's Carnival), set up in the United States Pavilion at the World's Fair in Brussels (D'Amico, 1960, p. 34). In the mid-90s, the High made the bold decision to move the interactive gallery from the lower level of the building to the main level – a demonstration of the increasing importance of family audiences at the institution (personal communication between Nicole Cromartie and Nichols Clark, May 31, 2020). Since then, the Museum's family spaces have taken many forms, stimulating the curiosity of millions of young visitors. Ongoing, periodic redesigns of the interactive gallery space have allowed education staff to respond to current research in the museum field and internal evaluations.

The High Museum opened yet another iteration of an interactive family space in November of 2005, designed primarily for children ages 5–10 to experience art with their caregivers and younger siblings. Now referred to as the Greene Family Learning Gallery, this redesign was informed by a study conducted by Marianna Adams of the Institute for Learning Innovation in 2003. The concept of the gallery was open-ended, creative play, in a space for families to visit before or after the High's art galleries. The Greene Family Learning Gallery was divided into five activity areas: Making a Mark,

Sculpting Spaces, Telling Stories, Transforming Treasure, and Building Buildings, with each area focused on the High's permanent collection and architecture.

In 2007, the High embarked on a four-year research study with the Frist Center for the Visual Arts and the Speed Art Museum to explore how families learn in art museum family spaces, funded by the Institute of Museum and Library Services (Institute of Library and Museum Services, 2010). This body of research elicited two key findings:

1 "Creative play" is one of the keys to the success of an interactive space.
2 Families highly value these types of spaces for the opportunity to create shared memories.

Full details from this study, conducted from 2007–2011, can be found on the Family Learning in Interactive Galleries site (Institute of Library and Museum Services, 2010). In 2018, another redesign to the Greene Family Learning Gallery took place. This most recent redesign, its goals, target audiences, and select activities will be discussed in Chapter 4.

Exhibitions for children and families

In 2015, the High launched two major exhibition series specifically designed to engage families – an ongoing series of Picture Book Exhibitions, and a rotation of outdoor installations in the High's Sifly Piazza (a striking outdoor area linking the buildings of the High, and its neighbor institutions, on the campus of the Woodruff Arts Center).

Picture book exhibitions

For many children, picture book illustrations are their first introduction to art. In 2014, the High Museum of Art collaborated with the Norman Rockwell Museum to organize and present *Witness: The Art of Jerry Pinkney*, "the first major exhibition to provide an overview of Caldecott Medal winner Jerry Pinkney's 50-year career as an illustrator and artist" (High Museum of Art, 2013). Building on the successes of this exhibition and related family programming, the High Museum developed a partnership with the Eric Carle Museum to present a new exhibition each year, exploring the art of picture books. The launch of this initiative kicked off with *Seriously Silly! The Art & Whimsy of Mo Willems*, on view 2015–2016. Exhibition design was informed by cross-departmental teams at the High and colleagues from the Eric Carle Museum of Picture Book Art.

While each of the picture book exhibitions has its own distinctive design, informed by the aesthetics of the featured illustrator, what collectively distinguishes these exhibitions from others are the family-friendly characteristics. The art is hung at a lower level than the traditional hang height of the High Museum which is 50–60 inches from the floor: the artworks in the picture book exhibitions are hung at 48 inches high (see figure 2.1). The Museum follows Developmentally Appropriate Practice (DAP) to meet younger kids where they are. Rather than needing an adult to hoist them up to see a detail in a work, they are able to observe freely without assistance. Rather than the typical neutrally painted gallery walls, the picture book exhibition galleries are splashed with brightly colored vinyl inspired by the front and end papers of the featured picture books. Each exhibition has an area for reading (either independently, with a caregiver, or in a facilitated story time format), with copies of multiple books. With each exhibition, the High Museum's neighboring Alliance Theatre has adapted the books for their stage: one story for families with children of all ages and one for families with children ages 0–5.

The High Museum collaborated with Oberg Research LLC on a three-year evaluation study to determine what makes a compelling family-focused

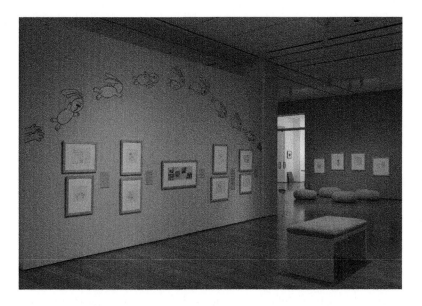

Figure 2.1 Exhibition view of *Seriously Silly! The art & whimsy of Mo Willems* at the High Museum of Art, May 2015 – January 2016. Photo by Mike Jensen/Courtesy High Museum of Art.

exhibition, and to inform the design of future picture book exhibitions (Oberg Research, 2017). Over the course of three different picture book exhibitions on view between 2015 and 2017, evaluators from Oberg Research interviewed both adults and children as part of an effort to answer these guiding questions:

1 What are the strengths of a picture book exhibition as defined by families with young children? Does this audience understand/appreciate that these exhibitions are not reproductions, but that this is authentic work that has been displayed in a more family-friendly way?
2 What impact does child-friendly design of a traditional exhibit have on families' attitudes toward the High and the artwork?
3 What connections are being made with familiarity of the work and comfort, enjoyment of the exhibition?
4 Does the data support or refute assumptions about how and why families with young children engage in exhibitions?

Oberg Research reported that, "family-focused, object based exhibitions," "support parents as they teach life-lessons to their children," "engage children and adults simultaneously," and "support connections based on what is familiar, beloved, personal, and intensely compelling" (Oberg Research, 2017). The adults who were interviewed for the study all commented on the family-friendly design aspects of the shows, including the hang height of the artwork, scavenger hunts, the availability of related books to read in a reading area, and the color schemes of the shows. Findings from this study have informed and encouraged the ongoing development of (and advocacy for) this initiative at the High Museum.

Sifly Piazza exhibitions

For many potential visitors, particularly those who don't consider themselves "art people" or "museum people," museum entrances can be intimidating. Tall staircases and heavy double doors flanked by white, classical columns have historically characterized museum entrances. The entrance to the High Museum is situated on a piazza space, shared with the entrances to the Alliance Theatre and the Atlanta Symphony Orchestra. At the eastern end of the piazza stands *House III* by Roy Lichtenstein, a nearly life-sized sculpture. Though this work is an enticing potential playhouse for children, it is roped off to discourage visitors from touching the artwork – a confusing or potentially unwelcoming first impression for families. With this in mind, in 2014 the curatorial and education departments collaborated to change the way High visitors first encounter the Museum.

Initiated in 2014, Sifly Piazza activations are free, interactive, outdoor exhibitions for families during the summer months. A new project has debuted on a nearly annual basis over the subsequent six years. Grounded in the belief that play is a unique platform for learning, the High created a new location for engagement on the public piazza – design interventions that would serve as a welcome mat for family visitors and as inspiration for audiences of all ages to visit, linger, and play. The stated vision for this program is to "harness the power of art and design to create an engaging, interactive, and playful introduction for visitors to the campus. Sifly Piazza activation projects are an integral part of the arts campus and a physical manifestation of the ideals and mission of the Woodruff Arts Center and the High Museum of Art to become a place where the community can personally connect with the arts" (High Museum of Art, 2014).

The High invites internationally recognized designers, represented in the Museum's permanent collection, to spend two years working with the Museum. These designers are selected for their whimsical approach to design and their sensitivity to the needs of families with young children. Once selected, the designers spend time on the Piazza getting to know the space and visitors and collaborating with Museum staff to engage visitors of all ages through interactive design installations.

Installations include *Sonic Playground,* designed by Yuri Suzuki (2018), *Merry Go Zoo,* designed by Jaime Hayon (2017), *Tiovivo: Whimsical Sculptures,* by Jaime Hayon (2016), *Los Trompos (Spinning Tops),* designed by Héctor Esrawe and Ignacio Cadena (2015), and *Mi Casa, Your Casa,* by Héctor Esrawe and Ignacio Cadena (2014). For each of these installations, the High staff worked with local arts organizations to present live performances and art-making activities themed around the works. According to intercept surveys conducted in the spring of 2015, visiting *Los Trompos (Spinning Tops)* was the overwhelming reason for a family visit to the Woodruff Arts Center campus, surpassing all other reasons for a visit to the High Museum of Art, The Alliance Theatre, or the Atlanta Symphony Orchestra that day (Alexander Babbage, 2015).

Programs and other initiatives for families

As discussed in Chapter 1, programs for children and families have developed significantly in recent years. The High's family programming is no exception, and has grown beyond hands-on art making and story times to encompass live performances, special tours, film screenings, and photo booths. In order to facilitate a variety of ever-changing offerings for families, the High employs both staff and contractors. The teaching artists and educators who facilitate the High's family programs are trained in a combination

of teaching methods: the Whole Book Approach, an interactive method of reading picture books with children (rather than to children) developed by Megan Dowd Lambert, a children's book author and scholar, when she was an educator at The Eric Carle Museum (Lambert, 2015); Visual Thinking Strategies, a research-based, learner-centered method of teaching visual literacy (Yenawine, 2014, 2018); the Reggio-Emilia approach, a philosophy developed by Loris Malaguzzi for early childhood education (Wurm, 2005); and creative movement, an open-ended and interpretive approach to learning through movement (Gilbert, 2015). These teaching methods inform specific programming designed to increase the attendance, engagement, and participation of families at the Museum. To better illustrate the growing list of offerings for young children and their families, we will explore a number of notable programs: Second Sundays, smARTbox, School Break Programs, Toddler Takeover, and Toddler Thursdays.

Second Sundays

Second Sundays, a free monthly program initiated in 2015, aims to remove the financial barrier of admission for families (at the High, admission is typically $14.50 for ages 6 and up and free for members and ages 5 and under), to provide access to the High's temporary exhibitions and collections, and to engage them in the Museum through family-centered programs. According to a 2013 Institute of Museums and Library Services study, only 43% of children with the lowest socioeconomic status visited museums in their kindergarten year, compared to 65% of children in the highest (Swan & Manjarrez, 2013). Removing the cost of admission is one of the first of many steps to addressing this disparity. A typical Second Sunday averages around 4,500 attendees and features a variety of programs to engage the entire family (infants through grandparents), in hands-on art making, special tours, performances, and story times. Second Sunday programming is conceptualized around a monthly theme, providing families another way to access and interact with the Museum and its exhibitions. Examples of past themes include: *Around the World in 30 Days, Take a Stand, Full STEAM Ahead,* and *Families in Space.* Intentionally designed to attract diverse visitors, Second Sundays are often devised in close partnership with other Atlanta organizations. High Museum staff recognized that partnerships add value by providing arts and cultural experiences that the High could not develop or deliver on their own. With one of the challenges being reaching families where they are, while encouraging participation at the Museum, the High prioritizes relationships with organizations that are deeply rooted in their neighborhoods. Examples include the Atlanta-Fulton Public Library System, Decatur Makers, The Georgia Haitian-American

Chamber of Commerce, and the Chattahoochee Nature Center. The High is also intentional about the performers and contractors hired to perform on these days: in an effort to ensure young visitors see themselves reflected, education staff regularly contract individuals with disabilities and from a diversity of ethnic backgrounds.

Another feature of Second Sundays is a bilingual family guide, each prompting a playful hunt which leads to several artworks currently on view. Through drawing exercises, games, and conversation starters, the family guides align with the monthly theme and provide a fresh set of looking activities for each visit.

smARTbox

One consistent concern expressed by caregivers to the High, from first time visitors to museum members, was that they didn't feel confident facilitating an experience with a work of art in the galleries with their children. Staff heard this expressed in a variety of ways: "With all of the different types of artwork on view, what should we focus on?" Or, "I know how to talk to my teenager about art, but not my 4-year-old niece. . . . What are we supposed to do?" One solution to this challenge was to create an in-gallery tool which offers some guidance in providing children with a way to be creative in response to what they see. The development of this tool occurred in concurrence with the launch of the Toddler Thursdays evaluation.

This tool (inspired in part by the Philbrook Museum of Art's My Museum program) was designed to provide families tools for engaging with art in the galleries and to extend the experience with art beyond the walls of the galleries. Children under the age of 13 who reside in the state of Georgia are able to register for free to receive an activity kit, stocked each month with a new art supply and art card (see figure 2.2). When the High instituted this program in July of 2017, the education staff were responsible for designing two separate, developmentally appropriate experiences for children. For example, the starter kit for children ages 6–12 contained a pencil, eraser, and sketchpad, while the kit for children ages 2–5 contained a pack of crayons and a sketchpad (at least in part due to the long-running Toddler Thursday program, the High's family audience contains a large proportion of children ages 5 and under). Each age group would also receive a developmentally appropriate supply of the month: each of these supplies would be related to a specific work on view, and could be used to create a work of art inspired by what they saw in the galleries that day. The monthly art card that accompanied each supply offered prompts for engagement with the artwork, and suggestions for the creation of an original work. A significant improvement on the Philbrook's original program took the form of bilingual art cards, printed in English and Spanish.

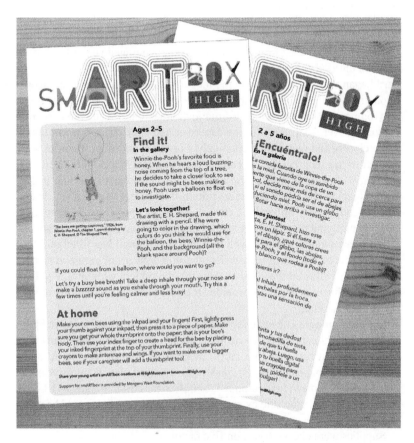

Figure 2.2 Bilingual smARTbox activity card for ages 2–5 inspired by *Winnie the Pooh: Exploring a Classic,* on view at the High Museum of Art June – September 2018. Photo by High Museum of Art staff/Courtesy High Museum of Art.

Designed primarily as a tool for families who were visiting the High, smARTbox was not marketed outside of the Museum. But once families arrived at the High, it was difficult to miss. A brightly colored cart, typically parked in the main lobby, was topped with a row of blue boxes families could see as soon as they entered. Children proudly carrying the vibrant blue kits, or working on an art project with their supplies, could be spotted throughout the Museum. Families wishing to sign up for the program would head for the cart, where a High Museum staff member would collect some information and then hand over a smARTbox. Additional advice would be provided: where to find the artwork on the card that month, and reminders

to come back each month to receive a new card and art supply. For some children, the kit itself was a delight, spurring the question, "Do I get to keep the box?!"

An example art card from December 2017 encouraged young families to view an untitled contemporary work by Laura Owens created in 2013. The card began with information on the location of the work, and a few words about the work itself. The information was tailored for an adult reader, who may or may not have read the information to their child. The second section provided several activities for the caregiver and child to engage in looking more closely and responding creatively. For this work of art, families were invited to use their bodies to recreate the lines and shapes in the painting, starting with their fingers in the air (great for a caregiver with an infant) then engaging their full bodies to mimic the squiggly lines in the work. The second activity utilized the crayons and sketchpad from their smART-box, encouraging them to make shapes inspired by the painting. The special monthly art supply provided with this card was a small bag filled with one square sheet of felt along with different colored pieces of yarn and ribbon. This activity allowed the child to work on the project while in the gallery in front of the work of art, or provided the caregiver the opportunity to save the project for later.

Supplies for ages 2–5 have included a watercolor set, easy foam and popsicle sticks (for carving relief sculpture), foam pool noodle fragments with fabric loops (in response to a fabric-wrapped sculpture), geometric shape stickers, tissue paper and contact paper (for a stained glass window project), and Magic Nuudles (for sculpture). Supplies for children ages 6–12 have included scissors, glue, and cyanotype paper. Some supplies would be given to both groups when deemed appropriate, such as ink pads and Wikki Stix.

Supplies were chosen based on five factors:

- connection to the featured work of art on the card
- age appropriateness
- whether they fit in the smARTbox
- individual cost allowed for bulk purchase
- didn't pose concerns for the collections or exhibitions teams if used in the galleries

School break programs

Looking to address the needs of families in search of appropriate activities when children are out of school, the High has long provided additional programming on the day after Thanksgiving and during the weeks of winter break and spring break. These programs are free with Museum admission

and often feature special tours and performances in addition to hands-on art making. Art-making activities for school break programming are designed with scalability in mind, to maximize participation on these typically busy days. Teaching artists also plan for a variety of projects and materials, to be appropriate for all ages.

Toddler Takeover

In 2014, partners on the arts campus, the High Museum of Art, The Alliance Theatre, and the Atlanta Symphony Orchestra, developed a special festival for early learners and their caregivers. Unlike Second Sundays or other family festivals which aim to engage the entire family, Toddler Takeover is designed for newborns through age 5 and their adults. This required a total rethink of what a collaborative festival would look like: not only the content of the programs themselves, but also thinking through logistical concerns for a family with very young children, including start times and scheduling, ease of navigation through the campus, dedicated nursing and changing stations, and working with food and beverage staff to ensure that there were appropriate food options available and accessible. This new experience featured infant and toddler gallery tours, story times, and art-making activities at the High Museum of Art; performances of original productions by the Alliance Theatre's Kathy & Ken Bernhardt Theatre for the Very Young, creative movement and family storytelling workshops by the Alliance Theatre; the Atlanta Symphony Orchestra's Music for the Very Young performances and instrument petting zoos. Taking place over the course of two days on the Woodruff Arts Center campus each spring, Toddler Takeover is now an annual arts festival that continues to evolve, shaped by the young children it serves.

Toddler Thursday

Programming for early learners and their caregivers has a long history at the High, possibly sparked by the Smithsonian Early Enrichment Center's (SEEC) seminal program. Founded in 1988, the program inspired countless educators to change their thinking around young children's ability to have meaningful experiences in museums. In the early 1990s, within a few years of the opening of SEEC, the High Museum initiated a Mommy and Toddler hour-long class. This class occurred on Thursdays, which was at the time a free day for the Museum, and provided caregivers with an educational and sensory activity to share with their child during the week. Former High Museum educator, Shantras Lakes, explains that the staff were charged with an expansion of programming following the 1996 Centennial

Summer Olympic Games in Atlanta, during which time the High had hosted a successful Olympics themed exhibition and related programs. In 1997, the Mommy and Toddler program was rebranded as Toddler Thursday and adjustments were made to the program to accommodate for growth (personal communication between Nicole Cromartie and Shantras Lakes, August 14, 2019).

In 2015, Toddler Thursday still drew on the same basic concept of the Mommy and Toddler class. It is a weekly, daytime program, an educational experience developed to foster caregiver and child interaction. Designed for children ages 15 months to 3 years, accompanied by a caregiver, Toddler Thursday serves as an introduction to the Museum and incorporates monthly themes through related artworks, art-making activities, and story times led by High Museum teaching artists. Toddler Thursdays are sibling friendly (removing a potential barrier to family participation), so infants through 8-year-olds are also regular participants, particularly during school breaks.

At the time of the evaluation, the program was scheduled between 11 a.m. and 3 p.m., giving families the flexibility to drop in anytime between those hours. Families would begin their experience of the program by checking in at the front ticket desk and receiving a handout with an image of the featured artwork of the week, the name of the art project, the title of the book being read during story times, and the locations of each of the activities. A part-time educator, referred to as a teaching artist, would plan the lesson for each week, selecting a work of art on view, choosing a related book to be read in front of the work of art, and then developing an art-making activity for family collaboration, situated in the High's toddler workshop, a traditional studio space scaled for child participation, with lowered tables and smaller chairs.

A plan from August 6, 2015 will help illustrate a typical Toddler Thursday program from this period. Families would be welcomed to the Museum and receive a handout from the admissions desk. Information provided included the date and time of the program, the location of the featured artwork, a short list of details within the work for families to look for, the title of the story time book along with the times for each reading, and a short description of that day's art-making activity, with the location of the workshop. On the reverse, a question was posed for the family to answer, related to the featured artwork.

Families could drop into the workshop portion of the program anytime between 11 a.m. and 3 p.m. They would be greeted by the teaching artist, shown a sample of a completed artwork, and given minimal instructions on how they might make their own creation. The workshop was typically also staffed by a volunteer during the busiest program hours, who refilled

supplies and helped to greet the families. At the time of this writing, Toddler Thursday has had the same volunteer for many years. Both the teaching artist and the volunteer learn the names of the Toddler Thursday "regulars," which creates a community feeling. Families who return each week develop relationships with each other, in some cases arranging set times to visit together each week, and sometimes setting up playdates outside of the High Museum.

Story times in the galleries were facilitated by a part-time family programs assistant and offered hourly on the half hour. The assistants, who regularly rotated (often leaving the Museum to pursue graduate school), had varying levels of proficiency facilitating read aloud activities. The story times were co-hosted by a grey, stuffed cat, called "Alex Catz," a namesake of Alex Katz, an artist in the High's collection. Alex Catz (the stuffed animal) greets families, offering hugs and high fives to children who are feeling unsure in the galleries. Alex Catz (and the other cats that have preceded and followed him, each named for an artist in the collection) serve as a constant for the children who attend Toddler Thursday. With a new location in the galleries each week and new storytellers from time to time, children know to look for Alex Catz, perched on a stool in front of a work of art.

The Greene Family Learning Gallery, though not formally a part of Toddler Thursday, became another "must stop" for families during the program. With no real artwork on display in this child-safe area, caregivers have said that this is a space where they can relax and let their children play without feeling like they have to be on guard. Unaccompanied adults are not allowed in the Family Learning Gallery, adding to the security of the space for roaming and free play.

Conclusion

With new activities each week, Toddler Thursday has always been a membership driver[1] for the High. Caregivers join the Museum so that they can return each week to enjoy free admission as a benefit of their membership. On the surface then, Toddler Thursday was working: it was the longest standing family program at the High, considered successful by families and Museum administrators. Nonetheless, High Museum education staff believed there was opportunity for improvement. When the High Museum identified the larger institutional goal of transforming Atlanta into a place where young children's exposure to the arts became an integral and widespread part of the city's culture, education staff took the initiative and set out to ensure that Toddler Thursday activities were meaningful, accessible, and developmentally appropriate. To this end, staff decided to bring in experts in early learning and evaluation to help better understand the program and the

needs of families with young children. Hopefully this chapter has provided readers with a broad sense of the High's programs prior to their evaluation study, detailed in the following chapter.

Note

1 High Museum Membership includes free admission to the Museum, subscription to a member magazine, discounts in the Museum shop, restaurants, and the Woodruff Arts Center parking garage.

References

Alexander Babbage, Inc. (2015). *Woodruff Arts Center Family Audience Programming Study: Summary of Ethnographic and Intercept Surveys* (p. 13). Unpublished report.

Atlanta History: A Journal of Georgia and the South from Spring-Summer 1994, Volume XXXVIII, Number 1-2

D'Amico, V. (1960). *Experiments in Creative Art Teaching* (p. 1). New York: Doubleday & Co.

Family Learning in Interactive Galleries. (2010) http://www.familiesinartmuseums.org/

Gilbert, A. G. (2015). *Creative Dance for All Ages* (Second Edition). Champaign, IL: Human Kinetics.

Hale, F. S. (2018). *50 Years of Creating Art Together: The History of the Woodruff Arts Center: Looking Back, Moving Forward: The Next Fifty Years*. Atlanta, GA: The Woodruff Arts Center/Atlanta Business Chronicle. www.woodruffcenter.org/wp-content/uploads/2018/11/WAC_50_Anniversary_Section_FINAL.pdf

High Museum of Art. (2013). *Witness: The Art of Jerry Pinkney*. https://high.org/exhibition/jerry-pinkney/

High Museum of Art. (2014). *Sifly Activation Planning*. Unpublished planning document.

Institute of Library and Museum Services. (2010). *Family Learning in Interactive Galleries*. www.familiesinartmuseums.org

Lambert, M. D. (2015). *Reading Picture Books with Children: How to Shake Up Storytime and Get Kids Talking About What They See*. Watertown: Charlesbridge.

Museum of Modern Art. (1969). *Short History of the Children's Art Carnival*. www.moma.org/momaorg/shared/pdfs/docs/press_archives/4224/releases/MOMA_1969_Jan-June_0057.pdf

Oberg Research, LLC. (2017). *The High Museum of Art, Children's Picture Book Illustration Exhibition Initiative, Visitor Research Part 3*. Unpublished report.

Shaffer, S. (2016). *Engaging Young Children in Museums*. London: Routledge.

Swan, D. W., & Manjarrez, C. A. (2013). *Children's Visitation to Libraries and Museums. Research Brief Series, No. 1*. Washington, DC: Institute of Museum and Library Services.

Wurm, J. (2005). *Working in the Reggio Way: A Beginner's Guide for American Teachers*. St. Paul: Redleaf Press.

Yenawine, P. (2014). *Visual Thinking Strategies: Using Art to Deepen Learning Across School Disciplines*. Cambridge: Harvard Education Press.

Yenawine, P. (2018). *Visual Thinking Strategies for Preschool: Using Art to Enhance Literacy and Social Skills*. Cambridge: Harvard University Press.

3 Improving the Museum for families

Program evaluation

When research meets an art museum

Dr. Kwon was excited to learn about the evaluation research for the Toddler Thursdays Program at the High Museum of Art. Not only does she have expertise in toddler development, family engagement, and program quality, she also loves art and museums. This was a perfect opportunity to leave her modest university office and work within the colorful, expansive galleries of the High. She looked forward to observing curious toddlers gazing at artworks; their busy hands cutting and gluing colorful paper pieces in the art studio; and joint engagement between toddlers and parents at play in the Museum.

Dr. Welch was also coming into this project excited to explore a learning space outside of a classroom or childcare center. She has young children of her own, and has often considered how and where they learn the most. Although she had been a High Museum visitor as a child on school field trips, she had not brought her own children to the Toddler Thursdays program and was not a frequent art museum visitor. Museum staff were excited to welcome their differing perspectives and experiences to the research.

The mission of this small-scale pilot study was clear: help the Museum improve the quality and accessibility of the Toddler Thursdays program. The evaluators pondered how the quality and accessibility of the program could be improved. They knew what accessibility and quality looked like in early childhood educational settings, but the museum space is an informal learning setting. An informal setting refers to out-of-school learning and/or free-choice learning (Falk & Dierking, 2000). Children and families' experiences can be open-ended and loose in a museum space and are less likely to be structured than in a formal educational setting. Learning opportunities are offered but not required by staff or instructors; visitors do not necessarily establish relationships with staff and instructors at the studio or during story times. Learning is voluntary, and while children might be self-motivated to learn, they need support from caregivers. There is a lack of standardized

measures to assess children's experiences or performance in informal learning settings (National Research Council, 2009).

The initial meeting with High Museum staff, including a brief tour of the Museum, established a mutual understanding and the creation of shared goals through an attainable plan. As researchers, coming from a different field (early childhood education and child development) the partnership with museum educators offered incredible opportunities across disciplines. The Museum staff may have had different understandings of how to improve the quality and accessibility of the program, and it was critical to identify their vision and expectations.

Research purpose

Developed collaboratively between the University researchers and education staff at the High Museum, the research purpose states why the research was conducted. Despite the value of art education and exposure to visual art for young children's development and the significant role of adults in the process, there has not been much attention paid in empirical research to experiences of young children and adults together in art museums. The research team examined the quality and accessibility of the Toddler Thursdays program (and toddler classroom space) for children and families from diverse racial and cultural backgrounds through (a) observation of the facility and interactions of instructors, children, and families, and (b) interviews with instructors and families on their experiences with the program. Based on the findings, researchers proposed recommendations that would enhance the quality of the environment and current practices to increase accessibility for existing and new audiences.

Research participants

Families or adult guardians with toddlers and preschoolers who visited the High Museum of Art were recruited on site to participate in the study. Ten caregivers of toddlers/preschoolers (ages from 19 months to 72 months) participated in the study. The majority of adult participants were stay-at-home mothers or mothers working from home. There was one babysitter and one aunt who participated in the study. The visitors for the program are mostly white overall from observation but we attempted to recruit families from diverse racial/ethnic backgrounds (i.e., oversampling families from racial/ethnic minority groups) to take diverse perspectives, especially on the accessibility of the Museum and the family programs. As a result, we recruited families who self-identified as Black (4), Asian (2), White (2), and Multiracial or Mixed Race (2). All participants identified as middle-class

families (e.g., at least a bachelor's degree and over half reporting an annual household income over 100K). The majority of the participants lived within a 10 miles radius of the High Museum of Art. Two participants lived more than 20 miles away and one was visiting from out of state.

The two instructors (one lead and one assistant instructor) who designed and delivered the Toddler Thursdays Program were also recruited for the study. Both instructors are white females working part-time for the Museum. The lead had been with the program for 8 years and had significant experience working with children in a preschool setting. She has no formal training in early childhood or art education. The assistant instructor had been with Toddler Thursdays for 5 months. She held an undergraduate degree in studio art and had experience working with children as a camp counselor and coach.

Research procedure and measures

To evaluate the Toddler Thursdays program, Drs. Kwon and Welch first secured approval from the Institutional Research Board (IRB) at Georgia State University, following appropriate consent procedures. This is an important part of the process of conducting research, which protects human subjects' rights and ensures confidentiality. The IRB procedures vary by setting and cultural context. In some countries, they do not have a formal standardized procedure in place for researchers to follow. However, many countries (including the United States and European countries) require researchers to receive appropriate reviews and approval before studies can begin.

In the United States, the IRB requires that participation be voluntary and that researchers obtain consent (typically in writing) from the participants. For young children, written consent must be acquired from an adult guardian prior to the study. Researchers should briefly explain the procedure to children using simple language, ask for assent (e.g., we are going to watch you playing with your mom and dad. I will take some notes. Is that okay with you? I am going to ask you a few questions about what you like about your visit here. Can I do that?). They are also clearly informed that they can stop participating at any time. It is required to take appropriate measures to maintain participant confidentiality (e.g., removing names and any identifying information from the data). Data must be managed and stored in a safe and secure place. Once approved, the IRB provides key documents stamped with an IRB number and date to be used for the study. Researchers followed this protocol for the High Museum study and received IRB approval.

Researchers used two key methods to capture children and families' experiences during the Toddler Thursdays program at the High Museum of Art: (a) observations and (b) interviews with instructors and program participants.

On-site observation was a major component of the study. Drs. Kwon and Welch visited the Museum to observe the facility (e.g., art studio, Green Family Learning Center), activities, materials, and interactions among instructors, caregivers, and children during art activities and story times. During each visit, a sign was posted on the toddler studio door informing families of the observations taking place that day.

Researchers used anecdotal notes, photos, and systematic observations of how the spaces were set up and organized. The following criteria (sourced from a variety of literature cited later) were identified by researchers to assess the quality of the physical environment in the museum setting (see Table 3.1). We used ratings of Low (the majority of quality indicators were not met), Medium (some quality indicators were met), and High Quality (the majority of quality indicators were met).

Drs. Kwon and Welch also observed children engaged in story time and activities in the art studio. These included conversations with the instructors and observations detailing how families and caregivers were encouraged to help children explore the materials, share experiences, and express themselves through the activities.

For observations of story times, researchers adapted the Classroom Assessment Scoring System-Toddler (CLASS-T; La Paro et al., 2012) to rate the quality of instruction and interactions between instructors and children. Dr. Kwon, the lead investigator on this project, is a certified CLASS observer. The CLASS tool is designed to observe the quality of instructor-child interactions during a regular routine in center-based early childhood settings through four to five 15-minute cycles. This tool has been field-tested and proven to be a valid and reliable means to measure the quality of instructor-child interactions in the domains of Emotional and Behavioral Support and Engaged Support for Learning. Within each domain, there are key dimensions that determine an overall domain score. The Emotional and Behavioral Support domain has four key dimensions including positive climate, negative climate, instructor sensitivity, regard for students' perspectives, and behavioral guidance. This domain is focused on instructor and child expressions of emotions, the responsiveness and sensitivity of the instructor, and the degree to which children's perspectives are considered and independence is fostered. This domain also focuses on the ways in which instructors interact with children to facilitate learning activities that effectively support development, learning, and language. The Engaged Support for Learning domain includes three dimensions: facilitation of learning and development, and language modeling. Each dimension is rated using a 7-point scale, with scores reflecting low (1–2), middle (3–5), and high (6–7) classroom quality.

The CLASS tool has been widely used in the field of early childhood and primary education (e.g., Vogel et al., 2015). However, it has not previously

Table 3.1 Environmental Assessment: Design Consideration

- Clean, safe, properly lighted, heated (or cooled), ventilated
 - The environment is free of materials or conditions that endanger children's health and is constantly monitored by the instructors for hazards
 - The environment is clutter free
- Home-like & culturally sensitive
 - Welcoming
 - Has the entryway that provides an effective transition area into the classroom
 - Includes private places to escape
 - Provides comfortable furniture and different types of seating
 - Filled with real, functional items (dishes, pottery, pots and pans)
 - Contains objects that have personal meaning such as framed art and collections of natural items (seashells, rocks)
 - Filled with images of the inhabitants through photos and mirrors
 - Has a private space available for a breastfeeding mom
 - Includes living things (plants, animals, flowers)
 - Contains a variety of soft elements
 - Has many materials that represent diverse learners and cultures
- Age-appropriate & child-directed & support for learning
 - Provides abundance of close-ended and open-ended materials
 - Provides materials which are challenging but not too difficult
 - Provides materials for a wide range of developmental levels
 - Places materials at the child level
 - Is not overstimulating
- Highly functional and flexible
 - Divided into usable space for different functions
 - Children are distributed evenly throughout the space during center time
 - Boundaries are movable so they can be changed as needed
 - Traffic paths are wide enough for children to move around
 - Centers are grouped according to whether they are quiet or active
 - Balanced between active and quiet areas
- Aesthetically attractive
 - Beautiful
 - Clutter free
 - Sensory rich
 - Thoughtfully organized
 - Attention given to detail
 - Abundance of natural lighting coming from at least two directions
 - Availability of different types of lighting (track, pendant, recessed, lamps)
 - Neutral or pale colors used for most walls, shelving, and flooring
- Adult-supported
 - Adult-sized furniture and instructors' materials handy at their level
 - Space welcoming for all adults
 - The arrangement of centers transparent to instructors so they can easily supervise and navigate the space
 - Matches their value of childhood and educating children
 - Space for privacy and personal time

(Adapted from Bullard, 2010; Kwon et al., 2019; Torelli & Durrett, 1994; Wittmer & Peterson, 2018)

been used in informal learning settings like art museums. Thus, to appropriately adopt this tool in the museum setting, researchers considered a few elements. Some interactions were too sporadic or short to allow an assessment of their quality. Therefore, researchers adjusted the length of the cycle (e.g., 10-minute observation time instead of 15–20 minutes; one or two cycles instead of full four to five cycles). Second, they needed to take into consideration that children might not be familiar with the space or the instructor. This might impact their behaviors and engagement with the activity. For example, some toddlers may exhibit a "stranger" anxiety and be reluctant to interact with the instructor. An instructor might also be hesitant to fully engage with families they do not know. In addition, while caregivers are likely to serve as a secure base for children, their presence could distract children from the activity. These distinctive circumstances were taken into consideration when assigning ratings. The tool was applied in the Museum during art activities, story times, and tours.

For observation of behaviors of (and interactions between) instructors, children, and families, researchers used unstructured anecdotal notes for children and families who consented to be observed. Anecdotal notes were used for the observation because these types of interactions are more sporadic and difficult to document or assess using a standardized observation tool than interactions during a story time, which is more structured and focused between an instructor and participating children.

Finally, Drs. Kwon and Welch interviewed ten participating families for 20–30 minutes on average, on-site, following their participation in the program. All adults who participated in the program with a child or children were invited to participate in the study. The researchers approached each participant and briefly introduced the study. If they agreed to participate in the study by signing a consent form, one of the researchers conducted an interview with them. Researchers asked about their general experiences with the program, the goals and reasons for their participation, and their suggestions for improvement. Additionally, two primary instructors who run the program (art workshops and story times) were interviewed about their experience, training, needs, and suggestions. The participating families received $10 in cash, one children's book, and a free parking permit for the High Museum's parking garage. The interviews were audio recorded and transcribed.

Data analysis

After completion of data collection, observational notes and photos were organized and carefully reviewed, ratings were assigned and comments added for each criteria of the Environmental Assessment Tool. Observational notes and CLASS ratings were also reviewed and organized to assess behaviors and the quality of interactions among instructors, children, and families during story time and in the art studio for the Toddler Thursdays Program.

Each interview transcript was reviewed in depth by researchers. Through open coding, the research team uncovered possible themes in the transcript that spoke directly to the experiences of participation in the program. Open coding entails the following process: listening and taking notes during the interviews, transcribing the interviews, and then reading through each interview numerous times. With each reading the researchers categorized and sought meaning in what the caregivers reported from different perspectives (Charmaz, 2003). The team continued to discuss and refine common themes until they verified the validity of the resulting themes.

Researchers conducted axial coding to examine the relationships among the initial themes to achieve internal homogeneity (grouping similar themes together as they are related through a common axis) and external heterogeneity (creating groups of themes that are clearly different from the other groups). Drs. Kwon and Welch also identified relevant quotes that best represented and illustrated each group of themes. The qualitative data analysis used is a phenomenological approach to identify and describe the subjective experiences of the participating families. The phenomenological approach "seeks to grasp and elucidate the meaning, structure, and essence of the lived experience of a phenomenon for a person or a group of people" (Patton, 2002, p. 482) and allowed the research team to explore the varied experiences of the families.

Finally, the research team conducted a content analysis of the information and materials related to the program that were available for families. This included information available on the website, signage, and in the program handouts distributed to each participating family. The information and materials were analyzed in terms of three criteria: accessibility, effectiveness, and appropriateness. Following data analysis, researchers developed recommendations for the program and wrote a report based on the findings of the study and feedback from three Georgia State University consultants: Dr. Melody Milbrandt, Stacey French-Lee, and Rukia Rogers. The report was organized in a PowerPoint format and presented to education staff at the High Museum of Art.

Research findings

This section consists of three parts: (a) the findings of this study from observation of the quality of physical environment in art studio, story time, and Greene Family Learning Gallery, (b) observation of interactions between adults and children in art studio and during the story time, (c) interviews with instructors and families about their experiences with the Toddler Thursdays program at the museum. The observation of the quality of physical environment using the environmental assessment is organized in Table 3.2. The observation of the quality of instructor-child interactions using CLASS-T is organized in Table 3.3.

Observation of physical environment

Table 3.2 Observation of the Quality of Physical Environment

Criteria	Art Studio		Story Time with Artwork		Greene Family Learning Gallery	
	Rating*	Comments	Rating*	Comments	Rating*	Comments
• Clean, safe, properly lighted, heated (or cooled), ventilated • The environment is free of materials or conditions that endanger children's health and is constantly monitored by the instructors for hazards. • The environment is clutter free. • The noise is not disturbing.	H	The room is bright, clean, and spacious to accommodate a number of families (e.g., 20–30 people). The room is well organized and clutter free (materials very well organized in the walk-in storage).	H	Story times take place in front of the themed artwork. The area is bright, clean, and safe. There is some light traffic but in general the area is quiet with minimal distraction.	H	The Greene Family Learning Gallery has potential as an engaging environment with ample space. The environment provides diverse loose-part materials (e.g., magnetics & board, wooden blocks) but they are well maintained. There are not many visitors, so the noise level is low.
• Home-like & culturally sensitive • Welcoming • Has the entryway that provides an effective transition area into the classroom • Includes private places to escape • Provides comfortable furniture and different types of seating • Filled with real, functional items (dishes, pottery, pots and pans)	M	Welcoming for children and families. Furniture is mostly child-size (no seating made with soft material). A variety of natural materials available for children to create artwork with (e.g., a variety of paper, wood sticks).	M	The artwork appears to be carefully selected and used to spark children's curiosity, and make a connection to the theme and the story they are going to read. The book and props are well prepared and organized in front of the featured artwork related to the theme and the book.	H	There is a mixture of open and closed spaces. This gallery provides different types of seating and comfortable furniture. Contains objects that have personal meaning such as framed art and collections of pretend play materials (e.g., different hats)

(Continued)

Table 3.2 (Continued)

Criteria	Art Studio		Story Time with Artwork		Greene Family Learning Gallery	
	Rating*	Comments	Rating*	Comments	Rating*	Comments
• Contains objects that have personal meaning such as framed art and collections of natural items (seashells, rocks) • Filled with images of the inhabitants through photos and mirrors • Has a private space available for a breastfeeding mom • Includes living things (plants, animals, flowers) • Contains a variety of soft elements • Has many materials that represent diverse learners and cultures		A nursing room is connected to the art studio and secured for privacy. There is enough room for accompanying children to play in the nursing room. No representation of diverse learners and cultures.		Books and props could be chosen to represent diverse culture and population.		
• Age-appropriate & child-directed & support for learning • Provides abundance of close-ended and open-ended materials • Provides materials which are challenging but not too difficult • Provides materials for a wide range of developmental levels • Places materials at the child level • Is not overstimulating	H	Chairs and tables are age appropriate and safe for children. Materials are safe, hands-on, and open-ended, which allows children to experiment and freely create artwork on their own or with minimal adult support.	M	Books are mostly developmentally appropriate in terms of content but are a bit too long and have too much text on the pages. It is neither over stimulating nor under stimulating.	M	There are a variety of materials (wooden blocks, magnets on magnetized wall, books, puppet theater, light table). Some materials are interactive and might facilitate children's active engagement (e.g., blocks, light tables). Other materials might encourage more passive engagement (e.g. observing) and might not sustain or extend play in meaningful ways in the space.

Although a sample product is presented alongside the inspiration artwork from the High's collection, there is no right or wrong way, or specific steps to create an artwork.
Art-making materials are easily accessible and well prepared.

H	M	L
Highly functional and flexible	Space is used by many visitors (ranging from 10–25 people at a time).	Space is open, with ample room for children and families to move around.
• Divided into usable space for different functions	Space is open but functionally divided by tables. Traffic paths are not wide but have enough room for children and families to move around.	It is a typical museum setting with artwork – participants are expected to be involved in quiet activities.
• Children are distributed evenly throughout the space	The tables are medium sized and can occupy 2–3 families.	
• Boundaries are movable so they can be changed as needed.	The tables were covered with butcher paper, so they are easy to clean up.	
• Traffic paths are wide enough for children to move around.	There is a restroom nearby but is not connected to the room.	
• Spaces are grouped according to whether they are quiet or active		
• Balanced between active and quiet areas		

The space is divided into usable space for different functions and balanced between active and quiet play areas.
The open space is flexible, and boundaries are movable, which permits frequent changes of the environment. Despite the potential, the space is not actively used. Children and families who stop by do not stay long – the space is not well used.

(Continued)

Table 3.2 (Continued)

Criteria	Art Studio		Story Time with Artwork		Greene Family Learning Gallery	
	Rating*	Comments	Rating*	Comments	Rating*	Comments
• Aesthetically attractive • Beautiful • Sensory rich • Thoughtfully organized • Attention given to detail • Availability of different types of lighting (track, pendant, recessed, lamps) • Neutral or pale colors used for most walls, shelving, and flooring	M	The walls are bare; there is no children's artwork or other information displayed. Materials are well-organized on each table The materials are colorful and appealing (e.g. creating flowers with various scrap paper and buttons on a wooden stick), but could be more sensory rich. Only fluorescent overhead lighting, but there is a lot of natural daily light.	H	The book and supplemental materials are interesting and visually appealing as they are arranged on an inviting area rug for the families to sit on.	H	New materials inspired by picture book exhibitions are added and coordinated during the run of the show (e.g., a child-scale interactive school bus for an exhibition on the work of Mo Willems, and a light table with caterpillar stools for *Eric Carle: I See a Story*). These materials are sensory rich, inviting, and thoughtfully organized.

Adult-supported	M	M	H
• Adult-sized furniture and instructors' materials handy at their level • Space welcoming for all adults • The arrangement of centers transparent to instructors and families so they can easily supervise and navigate the space • Matches their value of childhood and educating children • Space for privacy and personal time	Space is welcoming for all adults. Tables are low and chairs are too small for adults to sit comfortably. There is no adult-sized chair for an instructor who greets families at the entryway. The space is open and medium sized, so it is easy to supervise and navigate the space.	Space is open and welcoming for all adults. Adults either stand or sit on carpet with their child.	Space is open and welcoming for all adults. The arrangement of the gallery is transparent to families. Space is large and consists of small areas, which permits personal time and privacy.

*Note: H = High; M = Medium L = Low Quality

Observation of interaction during story time

Table 3.3 Quality of Instructor-Children Interaction During Story Time

Domains	Dimension & Description	Rating*	Researchers' Observation Notes
Emotional and Behavioral Support	**Positive climate** (reflecting the connection, warmth, respect, and enjoyment between the instructor and children)	H	Instructors are generally positive in their interactions with children. Instructors are often sitting with and interacting with children in a positive and respectful manner (e.g., Are you ready to make some art? You look ready! Can you give Alex a hi-five? Yes, great! [Both the instructor and children smile]). The instructor remembers several children's names and calls them by their first name. Children in general appear to be comfortable around the instructor and occasionally approach her to seek assistance.
	Negative climate (reflecting the level of expressed negativity in the classroom)	H	This is an area of strength for this classroom. The instructor does not yell, make threats, or use physical actions without explanation to establish control. The instructor never expresses negativity toward the children.
	Teacher sensitivity (reflecting the instructor's awareness and responsiveness to children's needs and emotions)	H	The instructor is generally aware of children's emotional and learning needs and responds quickly to bids for attention or assistance (e.g., A child asks, "Does a cat live in there?" the instructor responds, "I don't know. Maybe. You never know. There may be some surprises here. Let's see"). She appears "tuned in" most of the time and provides comfort (e.g., the instructor introduces Alex Catz (like artist Alex Katz) as the listener at the High. The little girl wants to hold the cat while they listen to the story. She acknowledges and accepts emotions and ideas (e.g., "This is a book about darkness. Are you scared of the dark?

[Child: No] You aren't afraid? Good. [Child: I am afraid] Me too. I am scared of the dark sometimes"). However, she misses a few opportunities to more deeply involve children with the story. For example, once a child's fear of the dark has been expressed, she could delve more into the child's experience by asking more questions (e.g., when did you feel afraid? What did you do? Did you get some help from your parent?) and connect to the main character's fear, and their experience of overcoming fear.

Regard for child perspectives
(reflecting the emphasis on children's interests, motivations, independence, and points of view in the classroom)

H

She is very child centered, as evidenced by encouraging child independence and facilitating/following children's ideas (e.g., Look at this piece of artwork. The artist didn't give it a title. Is there anything that comes to your mind? [Child: Racket] Oh, yes, it looks like a Ping-Pong racket. Any other ideas? [Child: Net, balloon, pool, etc.] Yes, net, balloon. These are great ideas! It does looks like the shape of a swimming pool).

Behavioral guidance
(reflecting the instructor's ability to promote behavioral self-regulation through proactive approaches and clear expectations)

M

The instructor monitors children's behavior and communicates clear expectations. The instructor sometimes reinforces positive behaviors and effectively redirects behaviors (e.g., Do we all have listening ears? Are we ready?). Children are fully engaged for periods of time.

At other times, however, the instructor is not very proactive and does not set the expectations early on. For example, after reading "The Dark" (Snicket, 2014), a story about a boy overcoming his fear of the darkness, the instructor asks children to come up and take out lights from a black container as a surprise. The children are very excited to touch and explore the light. Some want to take it with them.

(Continued)

Table 3.3 (Continued)

Domains	Dimension & Description	Rating*	Researchers' Observation Notes
			Some mothers ask if they need to give the light back and the instructor says, "Yes, I need to get it back for the next group." She could have been more proactive and communicated clearer expectations. Some children are distracted and wandering about the area and the instructor has to rush through the book at the end. Slowing down the pace and engaging children in more songs, movements, or finger puppets would help them better understand the story and sustain their attention.
Engaged Support for Learning	**Facilitation of learning and development** (reflecting how well the instructor facilitates activities, expands children's understanding, and how engaged children are in activities)	H	The instructor is actively engaged with children and uses gestures, facial expressions, and variations in style and tone of voice effectively. She provided opportunities for learning and guided exploration and thinking (e.g., "What is your favorite piece of artwork in this room? What do you like about it? I like that one, too, it's really colorful."; "Which one do you think is Sam and which one is the imaginary friend? How do you know?"). The instructor had comments and verbal exchanges mostly with older children (e.g., preschoolers) who sat near her. The pace of reading was somewhat fast for toddlers.

She also sometimes related children's lives and prior experiences and encouraged divergent thinking (e.g., "Have you been to the Muniz exhibit [the temp exhibit]? He did the Mona Lisa out of PB&J"; The instructor asked, "When you look around, is it dark or bright here? Where does this light come from? Does the light come from the sky? Does it come from here [points to the window]? Is it daytime or nighttime? (Child: daytime!) Yes, it's daytime. (Child: We see clouds and moon at night) Yes, we see clouds and the moon at night. That's a good example." She could've done this more and extended a little further by making more connections |

M	**Quality of feedback** (reflecting the degree to which the instructor provides feedback, how much individualized support the instructor provides to the children, the information the instructor gives to further student learning, and the encouragement and affirmation the instructor provides directly related to individual children's actions and language)	During the observation, the instructors provided children with specific feedback but most of the time, the feedback was a bit general and less process focused so it did not deepen their learning or engagement (e.g., "What do you think this is made out of? (Children: brick, metal, wood)? Great! This is a secret. [Points to the description of the artwork and reads]. This tells you about what it is made out of. Yes, you are right. It is made of paper and wire, which is metal. Great suggestions!" However, at other times, feedback was brief and simply repeated what the children said, with few extensions. In order to continue to improve the quality of feedback, the instructor should focus on sustained dialogues (feedback loops) with children to help children clarify their own learning misconceptions and to talk for extended periods about a single topic. The instructor occasionally offered encouragement and affirmation specific to children's efforts that expanded children's involvement, but not very often.
H	**Language modeling** (reflecting the quality and amount of the instructor's use of language-stimulation and language-facilitation techniques, including supporting children's language through back and forth exchanges, repeating and extending what children say, using self and parallel talk (e.g., describing an instructor's or a child's actions, respectively), and use of advanced and descriptive language and labeling)	The instructor frequently conversed with older children, using self-talk (i.e., a teacher narrating what they are doing as a teacher) but using less parallel talk (i.e., a teacher narrating and talking through what a child is doing side by side) and mapping actions to words (which helps toddlers understand what they are doing and why). The instructor used a mix of open-ended and close-ended questions that facilitated children's language and thinking (e.g., "What present do you think the dark would give to the boy?"). The instructor sometimes repeated what children said and occasionally provided additional information, but could do more to recast their comments into longer sentences, and by having more extended, back and forth exchanges. Strive for more back and forth exchanges that promote language and thinking.

(Continued)

Table 3.3 (Continued)

Domains	Dimension & Description	Rating*	Researchers' Observation Notes
			Although the book is carefully selected to compliment the theme of darkness, it is beyond toddlers' developmental levels. There are a lot of words in the book, and the instructor has to skip and simplify the language.
			The instructor used a variety of words and advanced vocabulary (e.g., perspective, dresser). When she introduced new concepts and vocabulary, she clearly explained what it meant (e.g., "Do you know what this instrument is? (Child: a violin!) Yes, it is a really big violin". She sometimes made connections to familiar words and ideas (In the folk art gallery, the instructor said, "These artists did not go to school to learn how to do art. They used the materials around them to do art. What about this (points to a horse sculpture)? What is it made of? Bottle caps! Like when you open a soda- that is what it is made of.")

*Note: Ratings on 7-point scales with scores 6–7 indicating high quality (H), 3–5 indicating medium quality (M), and 1–2 indicating low quality (L).

Observation of interaction in art studio

Overall, interactions between instructors and children/families in the studio were positive. A lead instructor warmly greeted families at the front of the studio, briefly explained the activity, showed a sample artwork, and provided materials to the family. The assistant instructor helped set up the materials. The instructors sometimes recognized children and welcomed them by name. They encouraged children/families to choose their own materials. The instructors monitored the whole classroom, checked on demands of materials, and added more if needed. They briefly spoke with parents before and after completion of the project. For the most part, however, they stayed at the front of the room and rarely engaged or interacted with the children/families after distributing the materials.

Children and caregivers spent time (an average of 15–20 minutes) creating an art project independently or collaboratively. Most of the children focused on the project and seemed to enjoy interacting with caregivers and creating their own artworks. They rarely wandered about or were off task. Most caregivers sat close to their child and offered assistance. Caregivers often participated by creating their own projects parallel to their child. While children and caregivers were often quietly engaged in the activities, there were occasional pleasant conversations between children and caregivers. For example, they talked about colors, different textures of paper, who they would give the flower they created, how their kites might move. Caregivers sometimes commented on the project, asked questions, repeated what a child said (e.g., "*Cut cut cut!*"). Caregivers sometimes provided guidance for behaviors (e.g., to share with others and behave respectfully in public, "*You need to share this with your friend. Could you share? You can use it after him.*"; "*I don't want you to mix the colors, though, other boys and girls need to use it.*").

Caregivers sometimes talked with another adult at the table or occasionally checked their phone. A few caregivers did not actively engage with their child and passively observed what they were doing. Time in the art studio typically ended when a project was complete, a child had lost interest (e.g., running around, leaving the room), a child was hungry and asked for food, or it was time to go to a story time.

Interview with family and instructor

Family interview findings

> I am planning to return every week as there is always something to do here, in a nice environment. She learns things when she comes here. She made a couple of friends here already. I talk to other moms, and she sits with other children. We made some friends here today; that is really nice. We see the same people coming, and children [of a similar] age.
>
> – Caregiver interviewee

Interviews were important to this evaluation, as they provided insight into the experience of the participants (caregivers and instructors) through their own words. The interviews offered opportunities to build trust with the participants and approach the topics of accessibility and inclusion based on race. Within a safe space of learning and stated intention of improvement, researchers could ask for candid feelings and responses to the Museum's efforts to be inclusive and expand representation. Researchers interviewed 10 Toddler Thursdays families (including parents and other guardians, such as grandparents) and purposefully recruited diverse (race, age, sex) participants to ensure varied perspectives. The two Toddler Thursdays instructors were also interviewed. Drs. Kwon and Welch interviewed caregivers in a small room intended for nursing, next to the Toddler Thursdays studio, and interviewed the instructors in the art studio following the conclusion of the program.

The researchers wanted to hear why, specifically, parents and caregivers brought their families to the Museum. Understanding these motivations can help the Museum to expand aspects that are working and improve those that are not. Further, the more the Toddler Thursdays program is connecting with participants, the more these cultivated relationships can serve to inform both parties – what are the clear expectations of the program? How can the program include more families?

Toddler Thursdays interview participants were from all over the metro Atlanta area. Most were High members and found out about the program from the member newsletter, local magazines, and social media; they did note, however, that information about the program was sparse. A few participants of color stated that many of their friends and neighbors did know about the program, and they had encouraged those friends to participate in the program. They came to Toddler Thursdays on a regular basis. Participants loved the hands-on experiences that their children took part in and felt that the space was welcoming and inviting toward young children – a feeling they had not experienced in other similar places.

Most participants found it worthwhile to purchase a Museum membership in order to participate in the weekly program, which would provide them with free admission at each visit. They mentioned the benefit of having a dual pass that allowed them to bring one additional adult (outside of their immediate family members) to the program. They found the affordability and flexibility very beneficial and appreciated the offering. Some members received additional discounts on the membership through Groupon. They mentioned that they were aware that the Museum offered free admission on one Sunday per month, and expressed a desire for the Toddler Thursdays program to coincide with this free day. Also, several families mentioned that the menus at the Museum café and restaurant were somewhat limited for children, and the food was expensive. The majority of the families brought their own food to eat at the open spaces in the Museum.

It is good that they make a different art activity each week. They create a very unique program outside of the box. . . . That's a reason for us to go out and do something that is always different. It is not something where they just paint – that is something I can do at home. . . . It brings value because it is different from something I do at home. I don't see this program as missing something or needing improvement. I think they just need to keep on with what they are doing. There are so many unique ideas to come up with.

– Caregiver interviewee

The participating families mentioned that instructors are very pleasant, friendly, and laid back, which made them feel comfortable. A few participants of color mentioned that although they did not participate in the program regularly, when they did join, they felt comfortable and safe. These families stated that they did not see many families from their racial group, but they wanted their child to engage in activities while interacting with other children from different racial groups. They felt like the High was an inclusive space.

All participants agreed that Thursday is a good day to visit. A few families mentioned that a weekday program was preferred, as it is not as busy as the weekend and they could feel relaxed and comfortable. However, they did mention that they would appreciate more day options (including weekend days) and extended hours of the program.

Caregivers felt that, through participation, their children might learn to appreciate art; to express themselves creatively (to become an artist); to sit and listen to a story (get ready for similar school experiences); to walk in an "adults' space" and keep quiet (and respectful); and to socialize with others (e.g., exposure to peers who have a different background). Their children might also develop fine motor skills, and make associations with things they already know (e.g., connecting the *Eric Carle: I See a Story* exhibition to the Eric Carle books they may have read at home). It is interesting to note that most caregivers who were interviewed did have some background in art (e.g., art instructor, architect, etc.).

It makes for learning with play – expressing herself creatively, which I also used to love when I was a child. Drawing, painting, it's just something else for her to try. If she experiences something new, she might say 'oh, I like this' and I will keep on doing it, it's in her nature. We strive for her to be active and to figure out what she wants to do. We want to encourage her to find out what she likes.

– Caregiver interviewee

Overall, the feedback that emerged from the interviews was very positive. Participants were very satisfied with the overall program quality, instructors,

structure/set-up, and materials. One participant noted that she felt like she couldn't complain because the program was free (with the price of Museum membership and/or daily admission). Suggestions for improvement included an adjustment of start/end times (citing wake times, lunch, and nap times); more information/publicity about the program; increased interaction from the instructors; recognition of anxiety surrounding active toddlers in art gallery spaces; and alternatives to expensive parking and food. Participants also offered new ideas to improve the program. These included guided mini-tours of the galleries for toddlers and their families; increased interactive/touchable artwork; and access to books in family spaces at the Museum.

> *Maybe the instructor can give more instructions. That's maybe more like an art lesson, but I like it.*
> *– Caregiver interviewee*

Instructor interview findings

> *The objective is to get young families to interact with the Museum, to get them more comfortable in the museum space. We accomplish this by having a featured artwork each week: we host the story time in the gallery and have gallery discussions, and then take an aspect of these discussions and create an art project focused on this aspect. There are a lot of offerings that draw families in, like the [Greene Family Learning Gallery]. If you didn't grow up going to museums, and you don't know a lot about art, it is intimidating.*
> *– Instructor Interviewee*

The lead instructor planned the themes and activities for each week (the read-aloud book, the piece of art to discuss in a gallery, and the studio art project). When planning, she made use of prior experience, discussions with the assistant instructor, current exhibitions at the Museum, and online resources. After themes and activities were set, the lead instructor would communicate them to Museum staff and would select materials based on the budget. The assistant instructor would publicize upcoming programs through the Museum website and social media. On program days, the lead instructor would facilitate the art studio project and the assistant instructor facilitated the story times.

> *It could be more engaging, especially in the galleries. Sometimes it feels like it could be a little more fresh. It's nice to have the consistency of repeat visitors, but then we feel like we could be less boring.*
> *– Instructor Interviewee*

Improved communication came up repeatedly during the instructor interviews. The lead instructor expressed a desire to be included in meetings as

a way to convey the current needs and opportunities for the program. This information could then inform budget decisions. She thought that regular communication with other Museum staff would keep instructors aware of special initiatives and events and, in turn, would allow Museum staff to implement changes or new ideas based on current feedback (from instructors and/or visitors). Both instructors had suggestions for different ways to facilitate art discussion in the studio and during story times, such as information for visitors in the studio (posters, books, a computer for the instructor to use), and guides in the galleries.

Summary of findings

Promoting quality experiences

High levels of satisfaction among families

Participants in Toddler Thursdays saw benefits to the program for both caregivers and children. Caregivers talked about giving their children the opportunity to play in the art space; an experience unique to the program. They sought to expose their children to art and community and expressed satisfaction with the program for fulfilling those ideals. They felt that the instructors facilitated the program extremely well and offered some support during each aspect of the program.

Quality of physical environment

Spaces in the Museum where families participated in the program set the stage for a high-quality experience. By choosing different artworks in different galleries, the instructors facilitated moving into new spaces that families might not have entered outside of participation in the program. They listened to a story in a unique space unlike any other program/story space in the city. While engaging in the art activity, families experienced a studio set up with a variety of hands-on and open-ended materials that allowed creative expression, self-exploration, and collaborative play for young children and their families. The majority of children observed were fully engaged in the activity while a parent or caregiver was supportive of the children's efforts and play.

High-quality interactions with instructors

Children interacted most frequently with instructors during the story time component of the Toddler Thursdays program. The story time was well prepared and organized with a book and props. There was a rug to sit on and a stuffed animal mascot as a model to help children feel at ease. Overall, the

instructor was positive and responsive to children's interests and questions and provided high levels of language modeling during the story. The instructor adapted well to the variety of ages participating during story time. Older children were more engaged and interacted more than younger children.

Opportunities for improvement

While feedback from families, analysis of the environment, and interactions with instructors were all high quality, there was some room for improvement. An additional space for young children in the Museum (not specifically used during Toddler Thursdays) could have been more functional and interesting. The art studio used during the Toddler Thursdays art activity was recommended to include more culturally representative art. Finally, professional development for the instructors would provide support around selecting developmentally appropriate books for toddlers and preschoolers, behavioral guidance, and a purposeful increase in interactions during the art activity.

Increasing accessibility for families from diverse backgrounds

Comfortable and welcoming space

Overall, the High Museum of Art is perceived by participating families as a welcoming and inclusive space. Families stated that the warm, friendly, and kind demeanor of instructors made them feel comfortable. The interactions between instructors and families were observed as warm and positive with some personal connections and recognition with frequently visiting families. The bright and clean space and open room arrangements at the studio also contributed to the families' feelings of comfort.

Culturally open and responsive environment and programming

Instructors and program staff were very aware and cognizant of the importance of being open and inclusive of families from diverse backgrounds and made efforts to integrate this into programming (e.g., sometimes selecting books representative of different cultures for the story time). The observed interactions of instructors with families were positive and respectful regardless of their cultural backgrounds. There were some play materials that have personal meaning and cultural representation, such as framed art and collections of pretend play materials (e.g., different hats) in the Greene Family Gallery, but there were few cultural representations in displays, books, play materials, and staff that children can interact with in other places. Adding play materials, books, children's work, and displays that represent different

cultures and hiring staff and recruiting volunteers from diverse cultural backgrounds would make the program more appealing and accessible to families from various cultural groups.

Diversifying the advertisement platform

Participating families discovered Toddler Thursdays through a wide range of sources, such as social media, friends, the Museum website, local caregiver groups, and news media. A few participants of color stated that many of their friends and neighbors were not aware of the program. Thus, more effective advertising and regular updates using various media (e.g., local radio, social media, newsletter, listserv, apps) could be implemented. More concerted efforts to promote the program to families from diverse backgrounds through other local connections and partnerships (e.g., partnership with local child care centers serving low-income families, churches; fundraising programs) would be beneficial to increase awareness and accessibility of the program to those families.

Affordability of the program

Most of the participants had an annual membership for the High Museum of Art and took advantage of the free admission for an additional guest with the annual membership. They mentioned that they enjoyed the free Toddler Thursdays program and special exhibits that targeted young visitors and their families. The affordability of the program is an important factor for most families with young children, particularly for families from diverse cultural backgrounds or families with limited resources.

Limitation of operation day and hours

Many of the participating families were satisfied with the weekday program (e.g., especially morning hours) as they can be relaxed and comfortably engaged in the program without facing the large crowds that are typical of other weekend family engagement programs at museums. This comment is representative of characteristics of the majority of current family visitors. They were mostly middle-class, stay-at-home mothers who are able to visit with a child during the daytime on a weekday. This is not applicable to many other families. As also suggested by participants, extending hours and providing more day options would make the program more accessible for families, especially those who are not able to visit the Museum during the daytime on a weekday, such as families who work full-time or have limited resources.

Convenient location in Midtown Atlanta but an issue with parking

Participants largely came from all over the metro city area, but some travelled more significant distances, including from surrounding states. The location of the Museum in Midtown Atlanta near a train station is convenient and makes it accessible for some families who prefer public transportation, such as trains or buses to the Museum. However, those who had made a long drive to visit reported that it is somewhat challenging to find public parking, and that parking at the Museum is expensive, even with the member discount.

Conclusion and implications for research

As educators and researchers, we would like children to be engaged in learning – to find learning pleasurable and meaningful. It is the role of adults to create high-quality environments and opportunities for learning everywhere. Learning is not limited to home and schools. Museums and similar informal learning settings serve as excellent venues to benefit even the youngest children and their learning. High levels of scaffolding and guidance from staff and participating caregivers would facilitate children's learning in this setting. In this chapter, two researchers examined the potential of the Toddler Thursdays program to make that happen. By analyzing the space, observing families participating in the program using both natural observations and standardized observation tools, and interviewing participants and instructors, the researchers were delighted to find great potential. They were able to ascertain how the program was operating, which informed their recommendations for improvement. They believe that the way the High Museum of Art respects and honors how children construct meaning through their experiences in the museum and seeks to maximize their learning and love of art sets the stage for an important life-learning connection with museums. In the next chapter, we discuss how these findings and suggestions are addressed and integrated to improve the quality and accessibility of the Toddler Thursdays program.

Although this small-scale pilot evaluation work has merit in the field, this study, with its limited sample size and scope, is not able to sufficiently capture the complexity of children's learning and engagement in the museum setting. A combination of qualitative and quantitative studies with a rigorous research design and a larger sample across different museum settings and time spans, and direct assessment with children's learning and engagement would be ideal (Andre, Durksen, & Volman, 2017). For example, a study with an experimental design that randomly assigns children to an experimental group who are provided museum experiences and studies their learning in comparison to children who do not experience the museum would be placed to gauge the real impact of museum experiences. We also call for the development of observational tools and child assessment tools that are easy and appropriate to use in informal learning settings for future studies.

References

Andre, L., Durksen, T., & Volman, M. L. (2017). Museums as avenues of learning for children: A decade of research. *Learning Environments Research, 20*, 47–76.

Bullard, J. (2009). *Creating Environments for Learning: Birth to Age Eight.* Upper Saddle River, NJ: Merrill.

Charmaz, K. (2003). Grounded theory. In J. Smith (Ed.), *Qualitative Psychology: A Practical Guide to Research Methods* (pp. 81–110). Thousand Oaks, CA: Sage.

Falk, J. H., & Dierking, L. D. (2000). *Learning from Museums: Visitor Experiences and the Making of Meaning.* Walnut Creek, CA: Altamira Press.

La Paro, K. M., Hamre, B. K., & Pianta, R. C. (2012). *Classroom Assessment Scoring System (CLASS) Manual, Toddler.* Baltimore, MD: Paul H. Brookes Publishing Co.

National Research Council. (2009). *Learning Science in Informal Environments: People, Places, and Pursuits.* Washington, DC: The National Academy Press.

Patton, M. Q. (2002). *Qualitative Research and Evaluation Methods* (Third Edition). Thousand Oaks, CA: Sage.

Snicket, L. (2003). *The dark.* New York, NY: Little, Brown and Company.

Torelli, L., & Durrett, C. (1996). Landscape for learning: The impact of classroom design on infants and toddlers. *Earlychildhood NEWS, 8*(2), 12–17.

Vogel, C. A., Caronongan, P., Xue, Y., Thomas, J., Bandel, E., Aikens, N., . . . Murphy, L. (2015). *Toddlers in Early Head Start: A Portrait of 3-Year-Olds, Their Families, and the Programs Serving Them* (Vol. 2: Technical appendices; report no. 28). Office of Planning, Research, and Evaluation (OPRE). www.acf.hhs.gov/sites/default/files/opre/bfaces_age_3_vol_ii_techapp_3_18_15_b508.pdf

Wittmer, D. S., & Petersen, S. (2018). *Infant and Toddler Development and Responsive Program Planning: A Relationship-Based Approach* (Third Edition). New York: Pearson.

4 Reshaping early learning and experiences in the High Museum

Findings and recommendations

Having received recommendations from the researchers the education staff began the process of sorting them into three categories:

1 Toddler Thursday program specific
2 additional areas for engagement for early learners
3 holistic museum experience for families

The first category was assigned to recommendations which were specific to the Toddler Thursday program and fit within the scope of the evaluation project. The second and third categories were for recommendations and responses which fell outside of the evaluation scope, in that they were not explicitly aimed at examining the effectiveness of Toddler Thursday, but rather addressed the holistic experience of families visiting the Museum for the program. The first of these non-Toddler Thursday categories was identified as concerning areas of engagement with families with early learners (like the children's picture book exhibition and the Greene Family Learning Gallery) and the second was for recommendations which fell outside of conventional educational aspects of the Museum (like parking and available food options). The following initial responses by High Museum education staff weren't seen as a definitive "final answer" to the evaluation's recommendations, but rather as a place to start. It is hoped that these initial reactions (along with the recommendations themselves) will provide some insight into the process of translating research into practice, and the real-world opportunities and limitations encountered by the education staff during this ongoing process.

Toddler Thursday recommendations

Researcher recommendation

Provide a brief, guided gallery tour in addition to story time.

Museum response

Developing a toddler tour was something that education staff had considered prior to evaluation and had already begun to develop. This new program was in response to caregivers' desire for deeper engagement with their children using dialogue focused on the art itself. With story time having always been the focus of in-gallery activities, the Museum enlisted outside expertise to help develop a framework for the tour which would be developmentally appropriate and engaging for families. The tour was a collaborative project between Nicole Cromartie, The High's manager of family programs at the time, and Sharon Shaffer, a scholar in the field of early learning and museums. Cromartie chose to work with Shaffer on the project based on her incredible depth of knowledge and experience working with early learners in museums. This tour for early learners would be the first of its kind at the High Museum.

In February 2016, Sharon Shaffer traveled to Atlanta to spend a day at the High Museum. During this time, Shaffer and museum education staff developed a schedule for the project, reviewed examples of early learner tours (both adult- and child-centered) at other museums and research on working with toddlers in museums, observed each component of the Toddler Thursday program, and brainstormed tour frameworks while touring the galleries. Following this visit, Museum education staff and Shaffer used their findings to develop a template for the tour and drafts of activities. The tour template provided a consistent routine for families, which could frame novel experiences each week in the galleries. Over the course of repeat participation in Toddler Thursday, this framework would become established ritual, increasing a sense of familiarity with the Museum and helping to "generate moments of deep connection-making and relationships" (Hackett, Holmes, & MacRae, 2020).

Knowing that the tour's content would change depending on which artworks were being viewed, the template for Toddler Tours would allow teaching artists to adapt activities each week based on themes and artworks. Designed to be physically interactive, 20-minute educational experiences, Toddler Tours are for children who are 15 months through 3 years, and their caregivers, although these categories were considered to be fluid since siblings who are younger or older often attend. The tours launched in June 2016 and were scheduled to replace story time every other week during Toddler Thursday. The tour template is divided into three sections: introduction, tour stops, and conclusion.

INTRODUCTION

The introduction is the most important part of any tour. It sets the tone, is a moment to develop rapport with children and adults, and sets expectations for the experience. It is likely that many families will have never participated in a gallery tour for very young children, and may have reservations about the experience – particularly the expectations of behavior for their child(ren). The tour introduction, and the conversations that may

occur beforehand as participants gather, are important opportunities to project confidence in the group and the guides' ability to lead the group. There are four components to the toddler tour introduction: a warm welcome, an introduction to the tour co-host, a fingerprint/mirror demonstration, and the plan for the tour, with housekeeping notes.

1 Warm welcome

This is an opportunity for the guide to welcome participants and introduce themselves.

Sample script:

Welcome, everyone! Come gather around! My name is _____ and I am so happy you're here! Thank you for joining us on our toddler tour of the Museum today!

2 Introduction of Alex Catz, the stuffed cat

Alex Catz, who has long served as the unofficial "host" of Toddler Thursday, was given an expanded role for toddler tours. Sharon Shaffer and High Museum staff discussed the ways in which Alex Catz's consistent presence has been a critical component to the Toddler Thursday program and how the stuffed animal might take on additional responsibilities around the sharing of gallery norms. Rather than focusing on the children's behavior and compliance with gallery rules, children were cast in the role of protectors of art in the galleries, and were asked to monitor Alex Catz's behavior, to make sure he was following the rules. This empowered the children as agents of preservation, much like the Museum staff.

Sample script:

Does everyone know our friend, Alex Catz? He comes to all of our story times and tours in the galleries. He loves hugs, high fives, and art! He gets excited in the galleries and sometimes gets a little too close to the artwork – we want to stay about this far away [raise your arm in front of your body to show a desirable distance away from the wall]. *If you notice him getting too close to a work of art, you'll have to remind me to tell him to keep his "paws up, tail up!"* [while saying, "paws up, tail up," model this by bringing the backs of your wrists to your chest, imitating a begging dog, and sitting up very straight.] *Can you all help me with that?*

3 Mirror demonstration

One of Sharon Shaffer's excellent suggestions (which could be used with children of all ages) was to add a small, handheld mirror to the teaching artists' tour bags. It is reasonable that children who are asked not to touch the artworks may want to understand why. It is not enough to tell them

that they can't touch in order to keep the artwork safe. The mirror trick is a perfect demonstration for curious children, as they can actually see the damage that can be caused, evidenced by the marks left on the mirror by their finger. This would also work with a cellphone screen if that is more readily available.

Sample script:

Do you know why we shouldn't touch the artworks that we see in the galleries? [Paraphrase and validate responses from children.] *Would you believe that we all have oils on our fingers? Do your fingers feel oily?* [You can rub hands or fingers together to model checking for oiliness.] *Me neither! Check this out!* [Pull out small, handheld mirror.] *When I touch the mirror with my clean finger, it leaves a mark of my fingerprint on the glass. Want to try?* [Hold out mirror for children to add their fingerprints.] *Look at all of our fingerprints! Can you imagine all of these fingerprints all over your favorite painting?! The oils you see actually damage artworks over time, so let's all be sure not to touch and remember that we're helping to keep the artworks safe for everyone to see.*

4 Plan for the tour: housekeeping

This is the moment to establish expectations of what the group will see on the tour, how long it's going to take, to answer questions, and share any other logistical details for the experience. It is important to assure families that they can leave the tour at any time, and that their tour experience should still be considered successful if they do.

Sample script:

For the next 20 minutes, we're going to explore the galleries. We'll look at art, share our ideas, and do some activities. We'll stick together as a group, but if you decide you're hungry, need to use the restroom, or are just ready to explore on your own, you can leave the tour at any time. This tour is for you! There are restrooms on each floor of the Museum with changing tables in each one. The café is on the lobby level with space to eat and drink. Does anyone have any questions before we get started? Alex Catz, are you ready? Let's go!

TOUR STOPS

Tour stops incorporate dance, drama, and tactile experiences to learn about art and museums. Each tour includes two distinct stops at two works of art. One stop's focus will be on tactile explorations, while the other stop connects to art through movement-based strategies. The tour stops are determined by the location of the featured artworks in the galleries. It is not important that tactile or movement-based stops fall in a particular order.

1　Tactile stop with cardboard box

There is a growing body of research about the benefits of multisensory learning, and of tactile experiences with art. In fact, an entire volume dedicated to the subject, *The Multisensory Museum: Cross-Disciplinary Perspectives on Touch, Sound, Smell, Memory, and Space* was published in 2014. This text presents research on the benefits of multisensory learning for young children, school-aged children, and children with disabilities including "increased student engagement," "better information retention," and "improved ability to multitask" (Levent, & Pascual-Leone, 2014, p. xvii). During each tour, families will have the opportunity to touch an object which relates to the work of art in some way, to make for a more meaningful experience. When discussing with Shaffer the different types of tactile objects that might be introduced, we developed a non-exhaustive list which would be applicable to many different types of artworks in many kinds of institutions:

- Tools used to create the work (e.g., paintbrush, palette knife, chisel, clay, wire, found objects, etc.)
- Examples of surface texture (e.g., unprimed and painted canvases, quilt squares, beads, porcelain plates and figurines, blocks of wood and marble, etc.)
- "Mysterious" objects found in works (e.g., various objects which might be seen in representational works of art, but not familiar to young children. These would vary by collection, but could include anything from an old-fashioned typewriter or different types of fabrics seen in clothing or in furniture upholstery to objects from nature like shells or a leaf from a particular plant.)

Before the tour, the tactile object is placed in a box in front of the work of art. A High Museum education staff member decorated a simple, printer paper box with metallic paper and cut-out stars. This simple and inexpensive prop attracts children's attention and piques their curiosity.

2　Movement-based stop

Many Toddler Thursday participants are pre-verbal and High Museum education staff have found movement and modeling to be not only fun and effective, but essential. When discussing with Shaffer the different types of movement-based strategies which might be introduced, we developed another non-exhaustive list:

- Tableau: This popular strategy encourages children to look very closely at a work of art so that they could mirror the body positions in the work using their own bodies

- Representing static aspects of a work of art through movement: this strategy encourages children to embody the movement of something that they have seen in real life (e.g., a bird, a swingset, a fan), or consider how something more abstract (e.g., a color, shape, or texture) might actually move through space, based on their associations with this particular feature of the work of art; this could also include representing the movement of art objects which were intended to move through space (e.g., rocking chairs, mobiles, costumes, etc.)

With the tour template developed, High Museum teaching artists would be expected to fill in the blanks each month and develop activities which fit with the featured artworks. The following movement-based and tactile-based tour stops were developed and facilitated by High Museum teaching artist, Nicole Livieratos, who details her approach to leading the experience.

Introduction
Alex Catz and I greet everyone and provide a welcome and introduction. Once we've moved to the galleries and found our first work of art, I start with a quick exercise with the group.

Transition to first tour stop
Let's all start by taking in a deep breath together while reaching up to the ceiling and looking up. This helps get oxygen to our brain so we're ready to look at art! [This is also a group management moment – a coming together that helps focus attention.] *Let's hold that for uno, dos, tres counts* [My fingers are showing the numbers as I say them.]. *Now breathe out making any sound you'd like.* [e.g., whoosh, ahh, zzzzzz . . .]

Tap your head lightly, tap all over; shake your hands, now shake all over [demonstrating as I give instruction]. *Cross your arms, now try your legs – we have two sides to our brain and this gets both going.*

Do you use your eyes in an art museum? Yes! What about these flappy things on the side of your head . . . I forget what they're called . . . oh, thank you . . . ears! Do we use those? Yes. Can you move in an art museum? Yes! Legs, elbows . . . yes! The only thing we won't

do is touch the artwork . . . so we'll stay back and you can point [I demonstrate.] *and I'll follow your finger to know what you're seeing.*

First stop: tactile stop

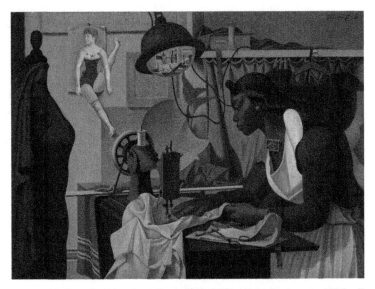

Figure 4.1 Francis Criss, American, 1901–1973, *Alma Sewing*, ca. 1935, oil on canvas, 33 x 45 inches. High Museum of Art, Atlanta, purchase with funds from the Fine Arts Collectors, Mr. and Mrs. Henry Schwob, the Director's Circle, Mr. and Mrs. John L. Huber, High Museum of Art Enhancement Fund, Stephen and Linda Sessler, the J. J. Haverty Fund, and through prior acquisitions, 2002.70.

I've pre-set our tactile box by the wall underneath *Alma Sewing* (ca. 1935) by Francis Criss (see figure 4.1). Inside the box are five different fabric pieces of varying sizes and four spools of thread. I ask *"What do you see in this painting?"* [answers include, "A lady", "a light", "a doll."] *Have any of you seen a machine like this?* [The children shake their heads "No."]

I ask: *Would you please touch your shirt, or pants, or dress? We wear clothing, and it is made by a person, sometimes with a machine like this – a sewing machine. What we wear is made from fabric or cloth. This person is pushing the cloth while a needle goes up*

and down to hold it all together with stitches. [I use my hands to demonstrate as I talk. I notice two children have applique on their clothing so with their permission, we all stay where we are but the focus is directed on the applique to notice the stitching. We look back at the painting.] *We know this person's name is Alma because the title of this work is "Alma Sewing." A person who sews is called a seamstress or tailor.*

Let's see what Alex Catz has packed in our box for today. Remember, please stay where you are, and I'll open the box so we can all see. [I have found this helps ensure that everyone can see and avoids a rush and grab energy. I tip the box a little sideways so everyone can see the lid come off.]

Ohhh, it's fabric! [I say as I take out the five fabric pieces. Small hands immediately start reaching out. I pass the fabric out, reminding all,] *We share here at the museum so when you're done, please pass it to a friend.* As we continue to talk, the children are feeling the fabric and I'm pausing to let them touch and look, adding more information and encouraging all to trade pieces to make sure everyone gets a chance to feel the material.

There are lots and lots of different fabrics. How do these feel? [Responses: "This one is bumpy." "This one is soft." "This one is crinkly."] There is one piece larger than the others. I demonstrate how when bunched up a little it creates folds. Everyone eagerly takes a try at creating folds with a piece of fabric. We look back at the painting and notice folds in the cloth.

I turn back to the box. *Alex also packed some spools of thread for us.* All look and touch and pass to each other. The caregivers participate in facilitating the sharing. We comment on the different colors and look at where thread is in the painting.

Let's put all our things back in the box. Thank you! I have one more thing to share with you. A sewing machine sounds like this. [On my phone I've downloaded the sound of an old sewing machine. I whisper] *"Let's listen"* [and everyone does].

We look up at the painting and recap what we see now, and I hear these comments: "a person named Alma", "a doll on the wall and she has cloth too", "a sewing machine" and the children add "ra-ta-tat-a-tat-a-tat", "I see folds", "I see a blue cloth" and I say, *Yes, it's called a curtain.* They now notice scissors and a pencil and someone says "snip-snip" for the sound of scissors.

Second stop: movement-based stop

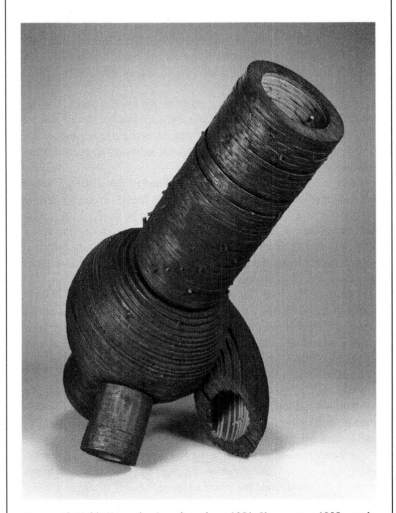

Figure 4.2 Heide Fasnacht, American, born 1951, *Viewmaster*, 1988, graphite dust suspended in matte medium on wood, 65 $\frac{1}{2}$ x 64 x 37 $\frac{1}{2}$ inches. High Museum of Art, Atlanta, purchase with funds from the Lannan Foundation, 1988.51 © Heide Fasnacht

Let's look at this piece of art (see figure 4.2). *What do you see?* [Participant response: "Circles!"]

You see circles? Let's all make a circle with your hand. Can you make a circle with your arms? With your legs? With a friend or your adult? Can you draw a circle in the air with your finger? With your shoulder? [We try all these options. Participants invent different ways to move in circles and we all try together. I mention a 3D circle is called a cylinder.]

Does this work remind you of anything? [Participant response: "Pasta!"]

You see pasta?! [We look at the sculpture, and I point out how the layers are set on top of each other, curving and almost spiraling. We spiral up and down from the floor, spiraling our arms. We curve our arms to look like spiralini pasta.]

Does anyone see something different? [Participant response: "A cannon!" Gracefully, a caregiver immediately suggests "a confetti cannon."] *A confetti cannon, let's all try that! How might that feel?* [We all jump and toss our arms up and out from our chests.]

What color is this sculpture? [Participant response: "Black! And brown!" We think about what color the confetti might be shooting from the confetti cannon and try jumping and spraying that everywhere with our imagination.]

Does anyone see something different? [Response: "A man doing push-ups!" A caregiver says, "Oh no!" and I say] *Oh yes!* [Laughing, we all do push-ups. Some try with one leg in the air.]

I ask one last time: *Does anyone see anything else?* [Response from a caregiver: "a telescope."]

We form our hands into the shape of a scope and look through it. We look up at the ceiling and the artwork.]

We sit down again to take a moment to look quietly at the art, holding all we've done in our mind and body.

Let's take in one last deep breath together with our arms raised and release that breath flickering our arms down like confetti.

Thank you so much for looking at art with me today. Alex is here to give a bye-five to anyone who wants one. See you next week!

Note: With 3–4 year-olds, I may ask "What makes you say that?"[1] This helps me clarify what they are seeing and helps them push their own communication skills. When doing this I've found it important to assure them their answer is fine – "Just help me see what you are seeing." or "Wow, I'm so curious about what you said, could you please tell me what makes you say that?" These are helpful phrases to approach this.

– Nicole Livieratos, Teaching Artist, High Museum of Art

Researcher recommendation

During story time, in general, the instructor is very active and responsive to children's interests and needs. She provides high-quality scaffolding that includes a variety of strategies to support children's stronger understanding and greater independence in their learning process (Vygotsky, 1978). We suggest the instructor continue with this effort. We also recommend that she be more proactive (i.e., setting clear expectations from the beginning) to effectively engage children (i.e., when they are distracted or not well engaged, through effective use of props, finger play, etc.) and provide more specific feedback (i.e., encouraging and recognizing effort and accomplishment).

Museum response

One of the major takeaways of this evaluation was the critical importance of story times: the selection of the books, facilitation techniques, and the experience of the individual who facilitates. At the time of the evaluation, this position was held by a part-time family programs assistant. Their responsibilities included helping with all logistics of Toddler Thursday as well as other family programs at the Museum. The individual who typically filled this role was someone who had recently earned their Bachelor's degree, often in art or art history, and who had an interest in museum education. Often, they had little experience working in education, but a burgeoning passion for museum education. Family programs assistants would often leave their position after about a year to pursue a graduate degree or to accept another position with more responsibility.

In response to the researchers' recommendations around story time facilitation techniques, the High Museum decided to shift the duties of the story time facilitator from a part-time assistant to an experienced educator from the High's existing teaching artist roster. Education staff felt that this was the best way to address this recommendation for several reasons:

• Story time is important. The researchers decided to use the Classroom Assessment Scoring System (CLASS) tool during story time rather than in the classroom because there was so much more instructor/child interaction than in the workshop. This was eye opening for education staff at the Museum. Previously, the High Museum educators responsible for planning Toddler Thursday saw the art-making activity in the workshop as the core of the program, with in-gallery story times being an opportunity to have an activity in front of the featured artwork of the week and to get families in the galleries. This evaluation highlighted the fact that there is incredible, untapped opportunity for engagement

with families and that having someone who is experienced and trained is ideal.

- The Museum's teaching artist roster is made up of part-time educators, but tends to be a less transient position. For example, the teaching artist who designs and facilitates the workshop portion of Toddler Thursday had been with the Museum for 8 years at the time of the evaluation. Having a more experienced and long-term staff member in this role would allow for more training on how to be more proactive, to effectively engage children, and to provide specific feedback. Additionally, more time in this role would allow for the teaching artist to grow and learn from their experience facilitating story times and developing long-term relationships with participating families.
- With the concurrent recommendation of offering a tour experience as a part of Toddler Thursday, this role was in the process of being reimagined. Having a more experienced educator in this role meant they would be better qualified to facilitate story times, but would also be well placed to design and facilitate successful tours.

With a new educator in this role, the High also decided that it would be important to learn more about the craft of storytelling. The High worked with Courtney Waring, director of education at The Eric Carle Museum in Amherst, Massachusetts, to provide a workshop on the Whole Book Approach. This method of reading books with children was developed by Megan Dowd Lambert, a children's book author and scholar, when she was an educator at The Carle (Lambert, 2015). For this workshop, the High Museum invited local community partners in addition to the entire museum education team and roster of teaching artists. Additionally, the High Museum education staff observed story times by the Youth Librarian at the Atlanta-Fulton Public Library branch located in the Museum's neighborhood.

Researcher recommendation

Offer an earlier start time (e.g., 10 a.m. for program & 10:30 a.m. for the first scheduled story time rather than 11 a.m. for program start and 11:30 a.m. for the first story time), and more than once per week if possible. Offering one additional day every other weekend or per month will be helpful to draw more families. This may be a more open and feasible option for those who are not able to come during a day time on a weekday such as people who work full time or have limited resources to participate in the program.

Museum response

Some of the recommendations, like this one, were very concrete. Prior to the evaluation, families could participate in Toddler Thursday between 11 a.m. and 3 p.m., but this prevented families with children enrolled in pre-school programs or children with a set morning nap time from attending. Based on this recommendation, the High extended the program hours so that families could drop in any time between 10 a.m. (when the museum opens to the public) and 4 p.m., one hour before closing. The first story time was set for 10:30 a.m. as recommended. This particular recommendation incurs a budget impact (paying staff for longer hours) but it was clear that the Museum was failing to serve a proportion of families with young children, which was central to the program's goals. The Museum also began to offer an additional toddler tour, each month on a Saturday.

In addition to providing more flexibility for participating families during the week, this measure also proved to be critical in attracting new families to the program, including those who would not be able to participate during the week or for whom the admission fee for the adult was a financial barrier. To help address this, the High added the newly launched toddler tours to monthly Second Sunday programming, during which time the Museum offers free admission.

Researcher recommendation

The lead instructor has created a very positive learning environment and has built relationships with the families. They have provided materials that are age-appropriate and interesting hands-on materials that foster children's curiosity and engagement. We suggest that they continue with these efforts. However, we recommend instructors increase engagement and language support in the art studio. Increased use and explanation of art vocabulary to unfamiliar visitors and those not comfortable in a museum setting would increase accessibility. For example, instructors should walk around, ask questions, and make and provide encouragement and feedback about projects and processes. Some resources for building art vocabulary in the art studio include Philip Yenawine's *Key Art Terms for Beginners* (Yenawine, 1995) and the Museum of Modern Art's online glossary (Museum of Modern Art, 2018).

Museum response

This recommendation sparked many discussions among program staff. Toddler Thursday teaching artists piloted several ways to encourage language support in the studio. As a team, they selected vocabulary words for each

lesson that related to the art-making project, featured artwork, and book. The words were mounted on the wall in the studio and were referred to by both teaching artists throughout the day.

Prior to the evaluation, the lead teaching artist in the workshop remained stationed at the front door to greet families, introduced the project, and offered supplies. The recommendation for the workshop instructor to move throughout the room and engage with families prompted reflective dialogue among program staff and teaching artists. Museum staff learned that the teaching artist's ability to walk around the room, confer with families, and offer encouragement was totally dependent on how busy Toddler Thursday was at a particular time. She felt that during slower moments, she was able to leave her post at the door to check in with families. Understanding that her engagement with the families was important to their experience shifted her perspective, and encouraged her to spend more time circulating the room and to encourage any volunteers (if present) to do so as well.

Researcher recommendation

Select age-appropriate books (e.g., short, simple, and repetitive; small, sturdy, and easy to handle such as board books and fabric books), and have multiple copies available for story time, in the picture book exhibitions, and in the Greene Family Learning Gallery. Children would love to revisit and reflect on the same stories/books during the visit.

Museum response

Selecting books for story time is an art in itself. There are so many considerations to make when choosing books for early learners. The Museum had worked with youth librarians intermittently in the past to help make selections for the story time portion of Toddler Thursday. With this recommendation, the Museum fostered a relationship with Ken Vesey, Youth Services Librarian for Atlanta-Fulton Library System, based at a branch across the street from the Museum.

Known as "Mr. Ken the Librarian" to his young fans from his library branch, Ken was not only close to the Museum, but also had a special interest in art and art history. The Museum asked if he would be willing to identify developmentally appropriate books with thematic connections to the featured artwork for the weeks that story times occur (first, third, and fifth weeks each month). He agreed and asked to visit the Museum to observe the program before starting to develop recommendations for the audience. He felt this was a critical first step in a collaboration with the Museum. Following his observation, education staff shared the themes and featured artworks

with Mr. Ken. Each month, he created a document that included thumbnail images of the featured artworks and the cover of the recommended titles. He also included the title, author, publisher, and date of publication. In his notes, he added a very brief synopsis of the book and why he chose it. For example, for *Gloria*, a flashe and neon work created by artist Mary Weatherford in 2018, Vesey recommended the book, *You Are Light* by Aaron Becker (2019). Vesey explains,

> This featured artwork combines real light and color much as this book does. There's more to this book than initially meets the eye. It's sort of an artsy approach to light. Maybe how an artist would interpret light. The die-cut pages and the translucent color inserts can be held up to a light source or a flashlight or LED shown through. What color is light? It depends on how it is reflected, what 'lens' it is seen through. And the short book ends with metaphorical light from an individual, the light is you, and you are light.
>
> (K. Vesey, personal communication with N. Cromartie,
> December 17, 2019)

For the second part of this recommendation, Museum staff considered the suggestion of stocking Toddler Thursday books in the Greene Family Learning Gallery and in the picture book exhibition's story corners. If the Museum took this on, it would entail purchasing two – three books per month and having a place to store them. We decided that this wasn't feasible due to budget and storage constraints and decided instead to focus on high-quality book selections for the program.

Researcher recommendation

Continue to provide a variety of hands-on materials and extend children's exploration. With the Museum's unique resources, the program can serve as a beacon to create a more visually provoking environment. Display children's artwork on the wall. The researchers shared images of *Reggio Emilia* classrooms to illustrate this suggestion. Reggio Emilia is "an educational approach and philosophy based on the image of a child with strong potential development and a subject with rights, who learns through the hundred languages belonging to all human beings, and grows in relationships with others" (Loris Malaguzzi International Centre, 2019). The images showed classrooms filled with natural light (which fortunately the toddler classroom already offered), plants and other objects from nature, art supplies beautifully arranged and accessible to children, and documentation of children's artwork on the walls.

Museum response

The toddler classroom is only utilized one day per week for Toddler Thursday; on other days it is utilized for school visits. The prior thinking behind the scarce decoration was to allow each teacher ample space to post any schedules, models, or other learning supports during their session. Following this recommendation, High Museum educators added several plants to the space and rotating displays of children's artwork from Toddler Thursdays programs.

Researcher recommendation

We recommend that the program provide more opportunities for collaborative and collective art, which can be another way to appreciate art and make children's experiences unique.

Museum response

High Museum staff saw several ways that they might be able to provide more opportunities for collaborative and collective art during each Toddler Thursday. Staff and teaching artists found potential connections in art making in the toddler workshop and during toddler tours. Additionally, collaborative art making was already being incorporated into the new Greene Family Learning Gallery design.

In the workshop, teaching artists began to experiment with ways that Toddler Thursday participants could collectively create art throughout the day. One of the first things that they tried was inspired by Howard Finster's *Gospel Bike, #1, 776.* This bike is painted white and completely covered in colorful drawings and text. Teaching artists drew an outline of a small bicycle and posted it on the wall, low to the ground. Children were offered a variety of materials to draw on the bike and add texture with collage materials that could be glued directly to the reproduction. Teaching artists continue to experiment with collaborative art making in the classroom and galleries.

Researcher recommendation

We strongly believe that instructors make extensive efforts to research and prepare for the Toddler Thursdays program. We suggest that the Museum provide extra time for planning, preparation, organizing materials, decorating the environment, and updating the program information.

Museum response

This recommendation helped High Museum staff understand just how much they were asking from teaching artists in planning for the Toddler Thursdays program. With this recommendation, High education staff reconsidered the responsibilities for each person who played a role in Toddler Thursday. At the time of the evaluation, the lead workshop instructor planned every element of the program- themes, workshop activities, and selection of the books. Responsibilities were shifted in the following ways:

1 The Manager of Family Programs took on the role of identifying themes and selecting appropriate artworks. Having more access to ever-shifting exhibition calendars and regular staff meetings, it was more efficient for the development of this element of the program to fall to a full-time staff member.
2 As previously mentioned, the evaluation underscored the importance of book selection and story time facilitation. Post-evaluation, High Museum staff asked Mr. Ken, the neighborhood youth librarian, to recommend age-appropriate books that would connect with the themes and artwork.
3 With a teaching artist taking the place of the family programs assistant for facilitating in-gallery activities, the assistant was now available to help the lead instructor in the workshop.

This reorganization allowed time for the lead workshop instructor to focus on planning quality workshop activities and shaping the classroom environment each week.

Researcher recommendation

One of the strengths of the program worth highlighting is the integration of themes across activities: story time, art projects, and artwork viewing. An even stronger and clearer integration of theme and resources across activities and informational materials would be possible when learning objectives are clearly set and displayed and instructors talk more about the connections (e.g., asking questions about what they made in the art studio, why instructors created those opportunities, and how children can make those connections; when families finish and leave, an instructor might encourage them to make sure to visit the featured artwork and story time to extend their learning).

Museum response

Following this recommendation, High Museum education staff and teaching artists identified additional opportunities for weekly themes to be reinforced throughout all elements of programming.

High Museum education staff instigated a Thursday morning meet-up with the guest relations team (who staff the front ticketing desk) prior to the start of the program, to explain the connections between the featured artwork, story time/tour, and art project that week. Since the evaluation, the guest relations team has been empowered to communicate to guests that the Toddler Thursdays program provides an interconnected experience that they can make full use of by participating in story time, tours, and art making, in addition to visiting the Greene Family Learning Gallery.

Researcher recommendation

Provide more staff support (e.g., regular volunteers and training for the volunteers). It is important to have regular staff and volunteers to provide the required stability and consistency for implementing and maintaining a high-quality program. Key instructors or professional staff in the Museum can train and support volunteers (e.g., by letting volunteers observe and shadow them in the studio and during story time and discussing effective strategies to set up activities and engage families).

Museum response

The Toddler Thursday program has been fortunate to have a consistent volunteer for the past 5 years. She has assisted with setting up workshops, greeting families, replenishing supplies at each table, and tidying up throughout the day. At times, other volunteers have expressed an interest in supporting the Toddler Thursday program, but have not been a consistent presence in the program. Volunteer support is an ongoing discussion for all family programs and initiatives.

Researcher recommendation

We suggest increasing the frequency of communication between Museum staff and scheduling regular meetings for input and planning purposes. Themes and possible activities can be discussed and planned together.

Museum response

Following this recommendation from researchers, High Museum staff instituted a monthly planning meeting for the Manager of Family Programs and the two teaching artists who facilitate the program. In this meeting, teaching artists share what has been working (and what has not), ideas for upcoming themes and activities, and questions and concerns that they may have. The Manager of Family Programs shares upcoming exhibitions, changes in the galleries, and any other relevant information that might impact the program.

Researcher recommendation

Provide professional development in early childhood pedagogy and developmentally appropriate practice. While having relevant experience and great skill in running a toddler program, neither of the instructors majored in childhood development or early childhood education. Thus, staff development opportunities should focus on how to engage and support young children's creativity and higher order thinking, possibly twice per year. The format could vary according to the emerging needs of the program. Examples may include (but are not limited to): (a) expert observation and debriefing; (b) participation in national/local early childhood education conference such as the National Association for the Education of Young Children Annual Conference, and the Georgia Association for the Education of Young Children Conference; (c) visits to local Reggio-inspired early childhood programs; and (d) in-house workshops with a guest speaker.

Museum response

Ongoing professional development is important to the education team at the High Museum. Staff at all levels are provided opportunities to participate in training that will enhance their practice as museum educators.

This evaluation, and the suggestions provided, prompted Museum staff to think more about targeted early learning training for the two main instructors of Toddler Thursday. Budget constraints were a major consideration in selecting opportunities for staff. Fortunately, the National Association for the Education of Young Children (NAEYC) Conference was hosted in Atlanta that year, in 2017. Because it was hosted locally, the Museum was able to support the participation of both Toddler Thursday teaching artists. In addition to attending sessions on developmentally appropriate practice by early learning experts, they presented a poster session at the conference on incorporating arts into the early learning curriculum, based on their learnings from Toddler Thursdays.

In addition to these paid opportunities, High Museum staff identified free opportunities for professional development within the Atlanta community through connections with the Talk With Me Baby initiative (www.talkwithmebaby.org) and facilitated group viewings of webinars offered by Read Right from the Start on Cox Campus (Rollins Center for Language & Literacy, 2020). Read Right from the Start offers a track of professional development courses for teachers who work with children from infancy through 8 years of age. Identifying opportunities for staff training remains an ongoing effort for High Museum education staff.

Researcher recommendation

Provide more guidance at the front ticketing desk. For example, the signage placed on the red easel in the main lobby is helpful. The ticketing desk provides the Toddler Thursday handout to families with young children, which is also great, but they can provide more detailed information regarding what programs are available and where they are located on campus. The handout can include learning objectives to make the program more focused and educational.

Museum response

The High Museum of Art is made up of three connected buildings and occupies 312,000 square feet. With Toddler Thursdays program components taking place in two locations, in a different gallery location each week, education staff recognized that wayfinding can be a challenge for families. Following the evaluation, the High Museum's education department worked with the Museum's creative services department to design branding for the program. Drawing inspiration from Toddler Thursday's stuffed cat host, the Museum's graphic designers created a playful cat face logo that can be seen on all relevant signage placed throughout the Museum on Thursdays. Branded signage is now placed not only at the main entrance to the Museum, but along the paths that families would take to experience all aspects of Toddler Thursday (see figure 4.3).

The program handout was completely redesigned following the evaluation. It includes the following information in both English and Spanish: title, date, and timeframe for the program, a detailed schedule for each program element (with wayfinding information), an image of the featured artwork (with tombstone, or caption, information about the artwork), and the location of the artwork in the galleries.

When education staff delivers the informational Toddler Thursday handouts to visitor services representatives at the front desk each Thursday morning, they share any special information about the program that day. Visitor services staff have the opportunity to ask education staff questions about the program at that time.

Researcher recommendation

Work with the Marketing and Communications team to develop effective advertising and regular updates using various media (e.g., local radio, social media, newsletter, listserv, app). For example, make a contact list/listserv and send out a newsletter on a regular basis.

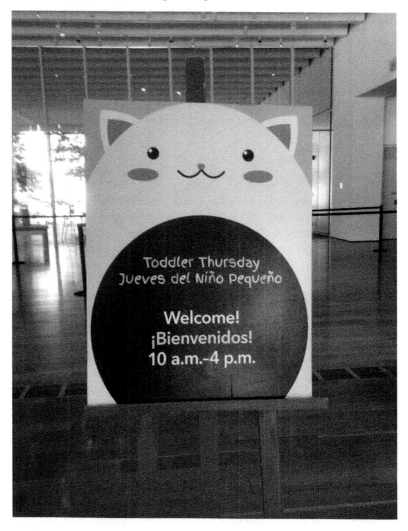

Figure 4.3 Bilingual Toddler Thursdays welcome signage on display in the High
Museum's main lobby. Photo by High Museum of Art staff/Courtesy
High Museum of Art

Museum response

There are several ways that the High Museum promotes the Toddler Thursday
program. Prior to the evaluation, these efforts were focused on an emailed
newsletter. Museum education staff had anecdotal evidence that many Toddler
Thursday participants had learned about the program via word of mouth. To
gather contact information for subscription to the newsletter, educators post a

sign-up sheet just inside the entrance to the High's toddler classroom. Families who have signed up receive monthly updates on all family programs at the Museum. Following the evaluation, the Museum also started promoting the program on an almost weekly basis on social media channels. Additionally, the Museum has worked to cross-promote Toddler Thursday during other High Museum family programs like Second Sundays, and during other early learning programs at the neighboring Alliance Theatre and Atlanta Symphony Orchestra.

Researcher recommendation

When advertising the program, target families with diverse backgrounds. For example, build partnerships with local childcare programs that serve low-income families with young children. Visit these programs and offer special packages with discounted parking and tickets.

Museum response

Eliminating all admission fees once per month during Second Sundays and year round for children under 6, opened the door to making the museum more accessible and inclusive for nontraditional museumgoers, including families with very young children. Additionally, the High added Toddler Tours to Second Sundays to address caregivers' interest in expanding toddler offerings to other days of the week, as expressed in visitor interviews.

According to census data, there are at least 146 languages spoken in homes across the Atlanta Metro Area (United States Census Bureau, 2015). When High Museum education staff learned that the second most spoken language in Fulton County (the county in which the High Museum resides) was Spanish, (Detailed Languages Spoken at Home and Ability to Speak English for the Population 5 Years and Over: 2009–2013, 2015), they determined that using Spanish in Toddler Thursdays marketing efforts could help attract more local families. The High Museum began producing handbills to advertise the program in both English and Spanish to help attract new, Spanish-speaking families.

Recommendations on additional areas for engagement for early learners (outside of evaluation project scope)

Researcher recommendation

More materials/activities (e.g., more open-ended and interactive materials for new creation; integration of books and props) and staff/volunteer presence is recommended in the Greene Family Learning Gallery. The staff person or volunteer can guide and engage children and families in the activities and help maintain materials and space in a clean and organized fashion.

Museum response

Plans for a redesign of the Greene Family Learning Gallery were already under way during the Toddler Thursday evaluation. The High's education department worked with ROTO design firm (www.roto.com) to create a new vision for the interactive space, based on a set of goals informed by years of visitor observation, input from community experts and family participants, and current research in the field. Dr. Meghan Welch was asked to serve on the community committee made up of individuals from around Atlanta who work in different areas of education, from early learning and design thinking to accessibility, to provide input on designs for the new Greene Family Learning Gallery. Dr. Welch was able to offer insight drawn from the multiple roles she has played at the museum – as a visitor without children, as a visitor with young children, and as a researcher/evaluator. She was able, along with several other early learning experts on the committee, to advocate and guide High Museum education staff toward designing with very young children in mind. With Toddler Thursday participants utilizing this space each week, how could the design of the new Family Gallery maximize their enjoyment of the Museum?

The resulting Greene Family Learning Gallery opened to the public in October 2018, doubling its previous footprint (to a total of 4,000 square feet) and occupying two spaces on the main level of the Museum. "CREATE," a bright and open studio devoted to developing young visitors' art-making abilities and centered on the creative process, and "EXPERIENCE," an immersive gallery that enables visitors to explore what art means, how it feels, and where it can take us. This design is the first at the High that includes separate spaces within the gallery for infants and toddlers. In planning for intentional inclusion, the community advisory team had a couple of major considerations in addition to creating engaging, developmentally appropriate activities for this age group.

During the week, a High Museum staff member periodically checks each space to engage with families, restock supplies, and ensure that everything is functioning properly. For high-volume days when the High Museum offers free admission, each room is staffed with multiple volunteers.

Recommendations on holistic museum experience for families (outside of evaluation project scope)

Researcher recommendation

Provide more of a discount for parking at the Museum with a membership if possible. Currently, member families pay $8 to park in the Woodruff Arts Center Parking Garage.

Museum response

When visiting the High Museum for Toddler Thursday, families have several options: public transportation, the Woodruff Arts Center Parking Garage, and on-street parking in the neighborhood. The parking garage attached to the Woodruff Arts Center campus is owned by a third party, so rates are not determined by the High Museum of Art. With a High Museum membership, families bypass High Museum admission fees and also pay a discounted rate for the Woodruff Arts Center parking garage.

Many visitors take advantage of the proximity of the Woodruff Arts Center garage and pay these rates on weekdays:

- First 30 Minutes: FREE (weekdays until 5 p.m. only)
- First 4 hours: $12
- After 4 hours: $17
- High Museum of Art Members (during Museum hours): $8

The cost of parking has often been identified as a barrier by potential visitors to the arts campus. The High Museum has maintained the membership discount for the parking garage while promoting public transit and other parking options in the area.

Researcher recommendation

Offer more food options for toddlers in the Museum cafe (e.g., finger food and more drink options).

Museum response

There are two dining options at the High Museum of Art – CJ's Café in the main lobby, and the High Café on the lower level of the Museum (conveniently located adjacent to the toddler classroom). Each eatery offers different food choices for visitors to the Museum. The High Café is a popular spot for families who are participating in Toddler Thursday to meet up, and eat lunch and snacks that were either brought from home or purchased in the café. Recognizing the importance of having food for children available, High Museum education staff have advocated for the inclusion of family-friendly foods on the menus at each campus restaurant. The food and beverage providers will change from time to time, so this is an ongoing effort on the part of staff.

Recommendation not included in the report

One of the major ways that Drs. Kwon and Welch influenced this initiative was in helping the museum consider how it was training families with young children to visit museum galleries. The artwork in the children's picture book

exhibitions, though displayed at lower heights, is not intended to be touched. There were occasionally instances of young children and caregivers touching works of art on display in these exhibitions. Education staff started to worry that interactions with security officers correcting this behavior would negatively impact families' experiences of the High Museum. After Drs. Kwon and Welch toured *Eric Carle: I See a Story,* the children's picture book exhibition on view at the time, they suggested that the High needed to present the rules for the gallery spaces in a friendly and intelligible way, for both children and their caregivers. For many young children, small artwork stanchions read as toys rather than barriers to the art. The elastic cord intended to keep visitors at a safe distance from the artwork is an object that evokes their curiosity. High Museum staff have observed young children pulling on the stanchion cord and testing elasticity and also treating them as track hurdles, something to jump or climb over. With stanchions drawing this kind of attention, they defeat the purpose of having them installed in front of artworks that the Museum wants to protect. So how else might the Museum communicate this gallery rule to families with young children? The researchers suggested creating a floor graphic of a small pair of shoes that would demonstrate the recommended viewing distance from the works of art on the wall. With no other floor graphics present, this would stand out, and particularly draw young children's attention as they are closer to the ground.

Following this recommendation, which was not a part of the official report, the museum originated the concept of the *Museum Friend*, which has been incorporated into subsequent children's picture book exhibitions (see figure 4.4). The initial Museum Friend signage text (modified as appropriate for each exhibition) follows:

BE A MUSEUM FRIEND
WELCOME to our special exhibition of art by _____!
We hope you are excited to see beautiful artwork and to be a good Museum Friend while you are here.
Who are Museum Friends?
Museum Friends are visitors who:

- Look closely at the artwork but do not touch.
- Help protect the artwork by standing two big steps away. (You can practice by standing on the footprints on the floor.)
- Ask – and answer – questions about what they see.

Who is a Museum Friend?
 You are a Museum Friend!

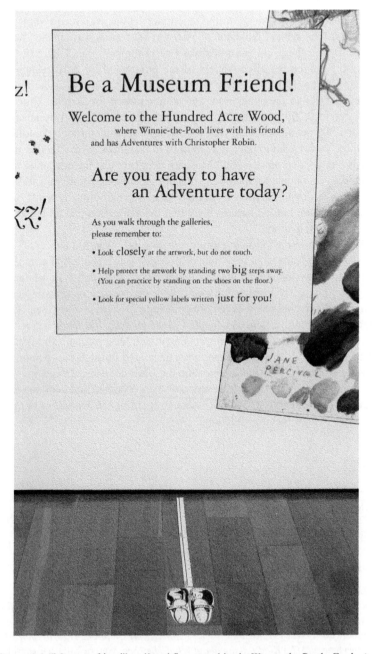

Figure 4.4 "Museum friend" wall and floor graphics in *Winnie the Pooh: Exploring a Classic*. Photo by Mike Jensen/Courtesy High Museum of Art

Conclusion

Were these initial responses to the recommendations well received by participants? One typical indicator of program success is participation/attendance. Before the evaluation, this was one of the key ways High Museum educators judged the effectiveness of the program. High staff recognizes that this isn't a definitive metric of success, but it is worth considering and tracking. Prior to the evaluation, annual attendance for Toddler Thursday was around 6,700 participants. Annual attendance increased by an average of 1,000 people from the year following evaluation through the following three years. Additionally, new initiatives like the Saturday toddler tours became so popular among High Museum members that the education team created a version just for members. It is not possible to definitively attribute the increase in participation to any one or number of improvements made on the program, but it's hard to deny that the evaluation had an impact on program participation.

The big question following any evaluation is, "Was it a success?" Did Museum staff learn what they hoped (or needed) to? The initial aim of the evaluation was for High Museum education staff to better understand a long-standing early learning program, with particular emphasis on accessibility, effectiveness, and developmental appropriateness. The researcher's report and recommendations provided Museum staff with perspective, and some concrete ways to make improvements on the program. The greatest value of the evaluation may have been generated through the relationship developed between the researchers and the Museum. Researchers provided recommendations outside of the scope of the evaluation and continue to be a trusted and valuable source of feedback regarding the Museum's ongoing response to their recommendations.

Note

1 "What do you see that makes you say that," is one of the facilitation questions for Visual Thinking Strategies, a method of teaching visual literacy (Yenawine, 2014).

References

Becker, A. (2019). *You Are Light*. Somerville: Candlewick Press.
Hackett, A., Holmes, R., & MacRae, C. (2020). *Working with Young Children in Museums: Weaving Theory and Practice*. Abingdon and New York: Routledge.
Lambert, M. D. (2015). *Reading Picture Books with Children: How to Shake Up Storytime and Get Kids Talking about What They See*. Watertown: Charlesbridge.

Levent, N., & Pascual-Leone, A. (2014). *The Multisensory Museum: Cross Disciplinary Perspectives on Touch, Sound, Smell, Memory, and Space.* Lanham: Rowman and Littlefield.

Loris Malaguzzi International Centre. (2019). *Reggio Emilia Approach.* www.reggiochildren.it/en/reggio-emilia-approach/

Museum of Modern Art. (2018). *Glossary of Art Terms.* www.moma.org/learn/moma_learning/glossary/

Rollins Center for Language & Literacy. (2020). *Read Right from the Start.* Cox Campus. https://app.coxcampus.org/courses/categories

Talk with Me Baby website. www.talkwithmebaby.org

United States Census Bureau. (2015). *Census Bureau Reports at Least 350 Languages Spoken in U.S. Homes.* www.census.gov/newsroom/press-releases/2015/cb15-185.html

United States Census Bureau. (2015). *Detailed Languages Spoken at Home and Ability to Speak English for the Population 5 Years and Over: 2009–2013.* www.census.gov/data/tables/2013/demo/2009-2013-lang-tables.html?#

Vygotsky, L. S. (1978). *Mind in Society: The Development of Higher Psychological Processes.* Cambridge, MA: Harvard University Press.

Yenawine, P. (1995). *Key Art Terms for Beginners.* New York: Harry N. Abrams.

Yenawine, P. (2014). *Visual Thinking Strategies: Using Art to Deepen Learning Across School Disciplines.* Cambridge: Harvard Education Press.

5 Building and improving early learning in your museum

It takes a village

There is no one size fits all solution. What worked for the High Museum of Art won't necessarily work for all programs or museums. The following recommendations are therefore intended to demonstrate a variety of suggested ways that museum practitioners who are looking to create an early learning program can get started, while also taking into account the particular needs, challenges, and assets of their institution. Whether you are just starting to develop a new program for early learners in your museum or you are looking to improve an existing program, working in collaboration with others will be key.

Toddler Thursday partnerships and advisory groups

Developing partnerships will provide valuable support in the creation of an early learning program which is developmentally appropriate and responds to the needs of your community. This section will showcase some of the partnerships that the High Museum of Art sought out to improve program quality through interdisciplinary and collaborative efforts, which benefits participating children and families.

If you are beginning the work of developing partnerships, start with a search for locals who have expertise in areas where your education department could use support. The High initially identified two areas where the Toddler Thursday program would have benefited from external expertise: (a) developmentally appropriate practice and evaluation, and (b) story times and book selection. These areas for support will continue to change as the program grows and develops, and will likely differ in various degrees for other organizations and programs.

The High Museum's Toddler Thursday program is built on foundational relationships with partner organizations and individual advisors and thought partners. In particular, the ongoing collaborative process

between researchers and Museum staff has been as important and influential as the initial, formal evaluation of the program detailed in Chapter 3. The researchers have become key collaborators for the program and its ongoing evolution.

Georgia State University: developmentally appropriate
practice and evaluation

Many communities will have a university or community college with researchers who may be able to lend expertise to museum practitioners. Atlanta, Georgia has many wonderful universities in the area and the High Museum has collaborated with several of them on different projects. The education department has collaborated with Georgia State University, specifically their College of Education and Human Development, on several occasions. In addition to facilitating an evaluation of the Toddler Thursday program, the researchers who partnered with the High Museum have recommended the following considerations for anyone starting an early learning program at their organization:

- understanding developmental characteristics and needs of diverse learners
- creating a sensory-rich, aesthetic, and interactive environment and developmentally appropriate and culturally relevant learning opportunities to engage children and families
- empowering children and families to view, respond to, and discuss artworks and express their feelings in creative ways
- letting children take the lead as guides and direct their own experiences in the museum while fostering reciprocal and meaningful interactions

This list of considerations, or your own organization's version, is also a good way to vet a potential partner. Are your goals and values in alignment?

The researchers, though neither of them are still working at Georgia State University, continued to serve as informal advisors for the Toddler Thursday program staff. Following the conclusion of the evaluation project, the family programs manager and the two researchers presented on the project at the American Alliance of Museums annual conference. When making choices about how to implement some of the evaluation recommendations, Museum staff reached out to the researchers to get their input. This ongoing relationship continues to shape the program and helps ensure its developmental appropriateness and accessibility.

Atlanta-Fulton Public Library System: story times and book selection

For many children, the first encounter with art takes place through the illustrations of picture books, read with caregivers. It makes sense for museums (particularly art museums) to build this familiar, universal, and developmentally important activity into early learning and family programming. If story times are a component of your early learning program, it's advisable to make friends with a local youth librarian. Ken Vesey, Atlanta youth librarian and advisor to the High Museum's programs, believes that the role of a public librarian is to be a resource to their community. Via email he has explained that although it is typical for youth librarians to work closely with schools, there are no public schools in the neighborhood of his library branch, which allowed him more time to work with the Museum, as well as area preschools (K. Vesey, personal communication with N. Cromartie, November 6, 2019). The High's relationship with this youth librarian was particularly fortuitous due to his personal interest in art, as well as his proximity to the Museum, which allowed him to occasionally facilitate story times, or pop in to see an artwork in person, in advance of providing book recommendations. An example of his book recommendations are referenced in Chapter 4 of this book.

If connecting with a local youth librarian isn't an available option, Vesey suggests other sources of book recommendations for your young audiences:

1 Start at your local library, with a self-directed search based on your needs:

 a Do an advanced search in the online catalog by the age range you plan to serve in your program.

2 Consult with other local experts:

 a Reach out to local school teachers or school librarians with experience working with and reading to the age group that you are targeting.

 b If your city has a university with a Master of Library Science Masters program, there may be a professor or student with a concentration in picture books who could offer guidance.

 c If none of these professionals are available to you, Vesey suggests meeting with caregivers who are passionate about reading stories aloud to their children.

3 Connect with national experts and resources:

 a Blogs by librarians – find the blog writer and message them personally.

b Already compiled lists – free resources – online and paid sub-
 scriptions, recommended book bibliographies in index format and
 online. The Ebsco company has an online subscription product, for
 example, called NoveList K-8 plus, which is searchable by sub-
 ject and age range. There are crowd-sourced resources for recom-
 mended books like Goodreads that might prove to be helpful.

The staff at the High Museum of Art also reference Jim Trelease's classic
Read-Aloud Handbook (Trelease, 2013). Initially published in 1982, this
text is filled with story time strategies, research, as well as a large selection
of Trelease's favorite books to read aloud, broken out by type and age group.

On the art of storytelling, Vesey emphasizes that the most important thing
is to "be adaptable, judge your audience, and modify as needed" (K. Vesey,
personal communication with N. Cromartie, November 6, 2019). Story time
in museums has changed since some of the earliest story time programs
were initiated in American museums at the turn of the century (Shaffer,
2016, p. 38). With the innovation of dialogic reading in the 1990s, story
time was no longer about a storyteller simply reciting the text of the book
aloud, or performing in isolation (Whitehurst & Lonigan, 1998). Resources
for current methods of story time facilitation include:

1 *Mother Goose on the Loose*, an interactive storytelling method devel-
 oped for caregivers with children from birth to age 3. Ken Vesey uses
 this method for his toddler story times at his library. It incorporates pic-
 ture books, nursery rhymes, puppets, play, music, and art. The Mother
 Goose on the Loose website has information and videos about the
 method, resources, and supporting research (Diamant-Cohen). Ken's
 infant story times, called "Love, Love Me Do: Storytime for 0–2" is
 based on Mother Goose on the Loose. Vesey recommends adapting
 recommended guidelines to match your audience and group dynamic
 as needed.
2 *The Whole Book Approach*, a story time model developed by Meghan
 Dowd Lambert at the Eric Carle Museum in Amherst, MA (Lambert,
 2015). Lambert says that, "The Whole Book Approach . . . is at its
 essence a means of reading picture books *with* children, as opposed
 to reading *to* them" and invites children to consider the whole book
 (including the artwork and design) in their interpretations (Lambert,
 2015, pp. ix–x). The Whole Book Approach draws inspiration from
 Visual Thinking Strategies for structuring inquiry-based discussions of
 artwork in picture books, and from dialogic reading conversations. The
 emphasis on reading and interpreting pictures makes this method par-
 ticularly attractive for museum programming.

Other partners and advisory groups which informed family visits

High Museum educators consulted with a range of additional external groups, like VSA and Talk with Me Baby, with the broad aim of improving programs and strengthening ties with the community. Although the following relationships weren't necessarily established to specifically inform the Toddler Thursday program, each contributed to the experience of families with young children visiting the High Museum.

VSA, the international organization on arts and disability (formerly very special arts): accessibility

VSA, the international organization on arts and disability, is housed at the Kennedy Center in Washington, DC. The High Museum has worked with both the National organization and the local VSA chapter, VSA Arts of Georgia, to assess and consult on facilities and family programming. Following tours of campus and observations of programs, VSA Arts of Georgia made recommendations around three main areas: (1) accessible entrances, (2) signage, and (3) lighting. One of the overarching pieces of feedback High Museum staff received about the popular monthly free day, Second Sunday, was that the Museum needed a quiet, sensory space for families to recharge. The High Museum has served as many as 6,500 visitors during free days and the Museum is filled with performances, tours, story times, and art-making activities. High Museum educators contracted with an expert on Autism Spectrum Disorder who helped the team design what would become a monthly sensory room pop-up space in one of the classrooms in the High's education center. To create the space each month, educators dim the lights, project a looping ocean scenes and sounds video, set up a crash pad space with foam floor squares, pillows, noise-cancelling headphones, and artist-created tactile storybooks. This space, which is included on the program map, sees a lot of use both by families with children on the Autism Spectrum, but also families just "looking for a break" from the crowds in the Museum, many of whom have very young children with them.

There may or may not be a local VSA affiliate or other accessibility consultant in your area. Fortunately, there are many resources online to reference on the Kennedy Center's VSA Research and Resources webpage (Kennedy Center, VSA Research & Resources) related to arts, education, and disabilities.

Talk With Me Baby: infant programming

Look for initiatives in your city that align with your program goals. In 2017, High Museum staff were determined to create a program for infants, but knew that it would be helpful to consult with experts in infant programming.

Staff set out to find individuals or organizations with expertise in this area. As mentioned earlier in this book, staff found the *Talk With Me Baby* website and determined from the incredible reputations of the organizations who came together to found the initiative (the Georgia Department of Public Health and Department of Education, Emory University's School of Nursing and Department of Pediatrics, the Marcus Autism Center at Children's Healthcare of Atlanta, the Atlanta Speech School's Rollins Center for Language and Literacy, and Get Georgia Reading – Georgia's Campaign for Grade Level Reading), that they would be a credible group to work with. High Museum education staff learned a great deal about the importance of talking with children during the first three years of life to support healthy brain development.

As outlined in Chapter 1, the High Museum education team worked with the Talk With Me Baby staff to develop their first infant program, Baby Book Club, based on applying their methods of supporting early language acquisition in the Museum's galleries.

Community advisory committee: interactive gallery design

When the High Museum decided to redesign The Greene Family Learning Gallery (as detailed in the previous chapter), Museum educators took the opportunity to put together a team of community-based experts to inform the choices in the project. This group of experts was formed from existing High Museum collaborators as well as individuals who were sought out specifically for their specialization in a topic that would benefit the design. The resulting advisory committee included experts in the areas of: Reggio Emilia, early childhood education, Science Technology Engineering Arts and Math (STEAM) learning, design, accessibility, and technology. This team played a role in every stage of development for the new Greene Family Learning Gallery: participating in a kick-off priorities brainstorm and meetings to review design, text, and graphics. Due in part to the expertise and advocacy of the community advisory committee, early learners were thoughtfully planned for from the outset of the project.

Professional development opportunities

As expressed by the evaluation recommendations in Chapter 4, ongoing professional development is critical. In addition to the training recommended by evaluators, the High's Manager of Family Programs attended the following conferences and workshops, and felt that each contributed to her knowledge and skills in facilitating an early learning program. There are many museum professionals who are responsible for starting and running early learning programs in museums who don't have training in early

learning. Taking advantage of available professional development opportunities will help. Conferences also serve as opportunities to present and share your work with other professionals who may have similar interests in family programming. They can help you extend your network and can become an invaluable partner in the future.

National and international

At the national and international levels, there are many opportunities to connect with other professionals who serve early learners in museums. Valuable and applicable knowledge can be acquired through learning about successful case studies, developmentally appropriate practice, and current research on brain development and other relevant topics.

In the United States, the National Association for the Education of Young Children (NAEYC) Annual Conference is a great place to start for someone new to serving young children. Although you won't find many other museum practitioners in attendance (the conference audience mainly comprises teachers, administrators, and researchers), many sessions will be relevant to your program. Presentations on cognitive development, learning environment, play, and diversity and equity were particularly informative for the Toddler Thursday program. The American Alliance of Museums (AAM) Annual Meeting, while not focused on early learning in museums, is an excellent source for best practices and successful case studies in museum practice. VSA, the international organization on arts and disability, hosts an annual Leadership Exchange in Arts and Disability Conference, referred to as LEAD.

There are several international conferences which also informed the Toddler Thursday program. The North American Reggio Emilia Alliance (NAREA) Summer and Winter Conferences were valuable introductions to the Reggio Emilia method through presentations by educators from Reggio Emilia, Italy (North American Reggio Emilia Alliance, Conferences). These conferences were also supplemented by in-person visits to local Reggio-inspired classrooms in the Atlanta area. The Early Childhood Music and Movement Association (ECMMA) Biennial International Convention was an additional useful resource that many art museum educators may not be aware of: High Museum educators were introduced to the conference by educator colleagues at the neighboring Atlanta Symphony Orchestra.

Local and regional

The large metropolitan city of Atlanta offered many local opportunities for professional development in early learning. Education staff participated in workshops offered by the state affiliate of NAEYC, the Georgia Association

for the Education of Young Children. Educators also attended workshops, including a bus tour of exemplary area preschools, facilitated by the Georgia Early Education Alliance for Ready Students (GEEARS). Look for local organizations who advocate for early learning as they may conduct trainings or be interested in partnering.

If conferences and workshops on early learning are not available in your area, there are still ways to support you or your staff's professional development. Toddler Thursday researchers suggested doing observations in local early learning classrooms.

Online

With each year, more opportunities for professional development become available online, particularly in the wake of the coronavirus pandemic, and the resultant shift to online resources during physical distancing. As mentioned in Chapter 4, High Museum staff identified free online professional development opportunities for the entire Toddler Thursday staff to partake in together. Group viewings of webinars offered by Read Right from the Start on Cox Campus (Rollins Center for Language & Literacy, 2020) allowed the team a cost-effective opportunity to learn and reflect together on how they would apply knowledge gained to their practices. Read Right from the Start offers a track of professional development courses for teachers who work with children from infancy through 8 years of age.

The next section will detail publications that are widely available which will support learning about early childhood development and programming.

Other resources for early learning program development and maintenance

There are several publications to help jumpstart early learning program development, including a number of volumes published by NAEYC. A great foundational text for those who have not studied developmentally appropriate practice or early childhood education would be NAEYC's *Developmentally Appropriate Practice in Early Childhood Programs: Serving Children from Birth to Age 8* (Copple, C., & Bredekamp, S., 2008). This text offers a thorough and easy to understand introduction to the concepts of developmentally appropriate practice, the development of children from birth through age 8, and examples of developmentally appropriate practice in action with different ages. *Developmentally Appropriate Practice: Focus on Infants and Toddlers* (Copple, Bredekamp, Koralek, & Charner, 2013) would be a great follow up text for any program serving these groups.

A further NAEYC text, *Expressing Creativity in Preschool,* is filled with practical strategies to encourage creativity in young students. Notable essays include an Art Learning Center Checklist (Colker, 2015, p. 38) which includes an actual checklist that includes materials as well as methods to extend children's play, and The Value of Open-Ended Art (Maynard & Ketter, 2015, pp. 4–9) which includes materials to support open-ended art making, and reflective questions.

Resources and toolkits for evaluation

Increasingly, museums are realizing that effective evaluation is not a solitary pursuit, and that an external body provides a vital perspective. However, while many museums recognize the importance of evaluation, they may not have the in-house skills or resources to work with a professional evaluator. Some scholars, like Elee Kirk, have discovered that their own research methods may be adapted for the purposes of evaluation (Kirk & Buckingham, 2018). Her recent publication, *Snapshots of Museum Experience: Understanding Child Visitors Through Photography,* will be of particular interest for museum professionals who are interested in the broader experience of children in museums, and in hearing directly from the children themselves. Using what she refers to as "photo-elicitation," Kirk asked 4- and 5-year-old museum visitors to document their visit by taking photographs. Following the visit, Kirk uploaded their photographs to her computer and asked the child to share information regarding the content and context of their photos. This approach centers children through a focus on direct interaction with them to better understand their experience, and Kirk suggests that it could be adapted to create an evaluation method with distinct differences from observational models. Depending on your needs at your museum, you may also draw inspiration from the following models if you are not able to work with an external partner to conduct evaluation.

The Adult Child Interaction Inventory (ACII)

The Adult Child Interaction Inventory (ACII) was developed by Lorrie Beaumont as an assessment tool for both exhibition development and evaluation at the Boston Children's Museum. ACII is an observation and interview instrument developed to answer the following questions:

- What verbal and nonverbal interactions are families using to support preschool children's STEM learning?

- What are the specific types of design strategies that support effective verbal and nonverbal interactions that can result in stronger STEM learning for preschool children?

(Boston's Children's Museum, 2010)

There are a couple of tools offered online that museum staff can download for use. There is a PDF guide which provides additional background on the tool (Boston's Children's Museum, 2010) as well as a data collection sheet, presented as a fillable form (Beaumont).

Dimensions of learning and broad facilitation moves

Four Dimensions of Learning and three Broad Facilitation Moves were developed at the Exploratorium in San Francisco, California to identify indicators of learning and the role of facilitation in learning. While observing what they define as "tinkering" activities, researchers identified four observable categories of dimensions of learning: engagement; initiative and intentionality; social scaffolding; and development of understanding. The facilitation moves describe how facilitators might spark interest, sustain participation, and deepen understanding for participants. The Exploratorium's website includes a description of the development of these frameworks, a downloadable video library of interactions used in research, as well as explanatory charts for both the Dimensions of Learning and Facilitation Moves (Exploratorium, 2015).

Museum of London's Early Years toolkit

The Early Years toolkit (www.museumoflondon.org.uk/toolkits/early-years-toolkit) is a substantial website filled with resources for working with children ages 5 and under. With separate sections for museums that are just starting with programs for early learners, those looking to grow, and even those who consider their programs established, this toolkit provides case studies, tip sheets, and a downloadable Under 5s Session Evaluation Form (Museum of London, *Under 5s Session Evaluation Form Example*).

Team-based Inquiry

Team-based Inquiry (TBI), developed by the National Science Education Network is not focused on evaluating early learning specifically, but is an assessment method focused on informal learning environments. Based on a cycle of question, investigate, reflect, and improve, TBI relies on the collaborative efforts of a team. In one of the examples of a successful TBI

process, the online guide cites the development of a preschool program for the Sciencenter and how the team was able to make a nanoscience activity designed for families with preschool-aged children more engaging (Pattison, Cohn, & Kollman, 2014).

OF/BY/FOR/ALL: a respectful toolkit for audience surveying

OF/BY/FOR/ALL was founded by former museum director, Nina Simon, to help "civic and cultural organizations to become of, by, and for their communities" (Vision, OF/BY/FOR/ALL website). The website provides several free resources including *Who's Coming: A Respectful Audience Surveying Toolkit*, designed to collect demographic data from visitors and developed in collaboration with Slover Linett Audience Research (Simon, N, *Who's Coming*, 2019). *Who's Coming* outlines a plan for collecting data as well as a template survey for museums to refer to when designing their own demographic surveys.

Conclusion

Evaluation is not a budget line for so many museums, large and small. It is imperative that museums who do conduct evaluation share their process and findings. In 2012 in Denver, Colorado, a group of staff from museums of varying sizes and content banded together in partnership to share evaluation resources with each other and build capacity among museum staff in the Denver metro area. The Denver Evaluation Network continues to meet on a monthly basis at rotating member museums.

Developing a new program or evaluating an existing one is going to be a different process for everyone depending on the context of the museum, the targeted audiences, and the goals of the program. The specific examples cited in this chapter are just suggestions and may not be of benefit to all. However, collaboration and relationship building are key components to any program's success. Not only will your program have the support of individual expertise, but you will also begin to learn more about your community as a whole. Through building relationships, the High learned more about meeting the needs of its community, and consequently became a more effective and valued component of that community.

References

Beaumont, L. A. *The Adult Child Interaction Inventory: A Tool for Exhibit Development and Evaluation.* Evergreen Research and Evaluation. https://static1.squarespace.com/static/50f6e23ae4b08fc5612b49a0/t/52265f84e4b00b01b752 65a3/1378246532722/ACII.pdf

Boston Children's Museum. (2010). *The Adult Child Interaction Inventory (ACII) and Resource DVD Guide.* https://static1.squarespace.com/static/50f6e23ae 4b08fc5612b49a0/t/522de357e4b0832d81b98768/1378739031494/ACII.Guide+ low+res.pdf

Colker, L. J. (2015). *Art Learning Center Checklist: Expressing Creativity in Preschool.* Washington, DC: National Association for the Education of Young Children.

Copple, C., & Bredekamp, S. (2008). *Developmentally Appropriate Practice in Early Childhood Programs Serving Children from Birth through Age 8* (Third Edition). Washington, DC: National Association for the Education of Young Children.

Copple, C., Bredekamp, S., Koralek, K., & Charner, K. (Eds.). (2013). *Developmentally Appropriate Practice: Focus on Infants and Toddlers.* Washington, DC: National Association for the Education of Young Children.

Diamant-Cohen, B. *Mother Goose on the Loose.* https://mgol.net

Exploratorium. (2015). *The Tinkering Studio: Learning and Facilitation Frameworks; Facilitation Moves.* www.exploratorium.edu/tinkering/our-work/learning-and-facilitation-frameworks

Kirk, E., & Buckingham, W. (2018). *Snapshots of Museum Experience: Understanding Child Visitors Through Photography.* Abingdon and New York: Routledge.

Lambert, M. D. (2015). *Reading Picture Books with Children: How to Shake Up Storytime and Get Kids Talking About What They See.* Watertown: Charlesbridge.

Maynard, C., & Ketter, K. J. (2015). *The Value of Open-Ended Art: Expressing Creativity in Preschool.* Washington, DC: National Association for the Education of Young Children.

Museum of London. *Early Years Toolkit.* www.museumoflondon.org.uk/toolkits/ early-years-toolkit

Museum of London. *Under 5s Session: Evaluation Form Example.* www.museumoflondon.org.uk/application/files/8215/2449/5147/EYT_Evaluation_form_example.pdf

North American Reggio Emilia Alliance. *Conferences.* www.reggioalliance.org/ events__trashed/conferences/

Pattison, S., Cohn, S., & Kollman, L. (2014). *Team-Based Inquiry: A Practical Guide for Using Evaluation to Improve Informal Educational Experiences* (Second Edition). Nanoscale Informal Science Education Network (NISE Net). www.nisenet. org/sites/default/files/catalog/uploads/TBI_guide_V2_Final_8-25-14_print.pdf

Rollins Center for Language & Literacy. (2020). *Read Right from the Start.* Cox Campus. https://app.coxcampus.org/courses/categories

Shaffer, S. (2016). *Engaging Young Children in Museums.* London: Routledge.

Simon, N. (2019). *Vision.* www.ofbyforall.org/vision

Simon, N. (2019). *Who's Coming? A New Audience Toolkit in Respectful Audience Surveying.* www.ofbyforall.org/updates-feed/2019/6/21/whos-coming-a-new-toolkit-on-respectful-audience-surveying

Trelease, J. (2013). *The Read-Aloud Handbook* (Seventh Edition). New York: Penguin Books.

Whitehurst, G. J., & Lonigan, C. J. (1998). Child development and emergent literacy. *Child Development* 69(3), June 848–872.

Conclusion
What's next?

Writing this book over the course of a year has provided an unmatched opportunity to reflect on our practices as museum educators and researchers. The authors have revisited the findings, questioned initial interpretations, and engaged with each other and the many additional collaborators picked up along the way. The toddlers who were involved in the study have aged out of Toddler Thursday, joining the High's summer camps, family days, and school tours. The Toddler Thursday program continues to evolve and develop in response to the researchers' recommendations and feedback from new families and staff. The learnings from this one small-scale evaluation study continue to influence the authors, informing their work and shaping their thinking, not only around *how* to best serve very young children and their families in museums, but *why*. Why strive to center this audience? To what end do museum staff dedicate time, energies, and resources in developing these programs, and continuously evaluating their efforts?

The answer lies, at least partially, in another big question: what's next? What new goals (and pathways to these goals) are being identified by others in our field? What's next for the High Museum of Art in pursuit of their aim – to make a visit to the art museum a hallmark of early childhood in Atlanta, Georgia? The High's current manager of family programs, Melissa Katzin, is exploring the idea of redefining "family audiences" and in turn, how she plans for them.

We have a slate of offerings designed specifically for different age groups, like Baby Book Club and Toddler Thursday, but we also have programs like Second Sunday, which is designed for the whole family. Family programs are often not considered as interage programming, but as programs designed for parents with young children – a narrower conception of the family. I think it's important to have programs

designed for specific age groups that are developmentally appropriate, and at the same time, I wonder what it would look like to design a truly intergenerational program. I see so many different types of family structures at the Museum. Recently, I've been having conversations with the High's Head of Creative Aging about collaboratively planning a grandparents day inspired by our current exhibition of children's picture books: Picture the Dream: The Story of the Civil Rights Movement Through Children's Books. Ideally, we could partner with a local organization for grandparents who serve as the primary caregivers for their grandchildren, on developing a program that would equally engage grandparent and child. I think we would learn a lot about what it means to plan for adults with varying abilities through this partnership.

We commissioned the Alliance Theatre to create an in-gallery drop-in performance series for families that would center the unique experience and expertise that they each bring into the galleries. An artist-educator from the Alliance, Sam Provenzano, developed Humans of the High. For the first iteration of this series, visitors encountered two actors playing aliens who had been kicked off of their home planet and were soliciting suggestions for a new suitable home, within one of the artworks on display. Participants would lead them to an artwork of their choice, and once the group had engaged in one minute of close looking together, the alien asked open-ended questions like, "Why do you think this would be a good home?" "What do humans look for in a home?" The concept of home, and other concepts that followed in the series, were ones that participants of any age have strong feelings about. The success of that program lay in its intentional design for an intergenerational family audience that includes very young children.

So how do you take that intergenerational approach to an early learning program like Toddler Thursday? We advertise Toddler Thursday as being "sibling-friendly" as we often see both younger and older siblings join. However, despite the fact the program is deliberately sibling-friendly, it's still essentially geared toward toddlers. We introduced a baby play area in the toddler classroom to create a sensory space for younger siblings, but we haven't yet incorporated plans to include older siblings. I am striving for an intentionally planned, full family-inclusive experience.

– Melissa Katzin, Manager of Family Programs,
High Museum of Art

(Personal communication between Nicole Cromartie and Melissa Katzin, August 15, 2020)

Katzin, like many other practitioners featured in this book, is interested in addressing the needs of each and every member of a family with young children. It seems this is often most successfully achieved when families aren't working adjacent to one another on parallel projects, but together, in a way that feels meaningful for everyone in the family. For other museums that have existing and long-standing early childhood programs, reassessing how your museum defines (and then designs for) family audiences may be a next step. For other early learning museum professionals, next steps may be outreach in the community, as demonstrated in the following example.

The National Museum of African American History and Culture (NMAAHC), a relatively young museum, opened its doors to the public in September of 2016 in Washington, DC, to "highlight the contributions of African Americans" (National Museum of African American History and Culture, About the Museum). They have quickly established themselves as a model in their approach to serving early learners and their families. Ariel Gory, their Lead Education Specialist for Early Childhood Programs, is driven to create meaningful family experiences for young children and their caregivers, and is considering ways to extend the reach of their infant programming beyond the walls of the NMAAHC, into their surrounding communities.

We're trying to figure out ways that we can be not only a national museum, but also a local one. Museum doors have been open to people, technically, for years and years. But there are other reasons why they don't come; some people have been made to feel that they shouldn't be there. When we're [museum educators] trying to invite new audiences, especially those who historically have not been welcomed, it doesn't help to just say, "Come on in, we have a program for you now." We have to acknowledge that history, get to know our local community, and then begin to build a relationship. The first community outreach program that I worked on for a local museum included some evaluation. Our evaluation revealed how difficult it can be for families to access and utilize museums, despite living within a few miles of the National Mall, due to several factors like transportation or a lack of access to information. So the next step for our infant program is to share it with folks in our local black and brown neighborhoods that don't typically have easy access to our museum, and do that in partnership with organizations that are already within and a part of these communities. We hope that through

> *relationship building within communities today, we can learn how to make our museum a welcoming space for generations to come.*
>
> *— Ariel Gory, Lead Education Specialist for*
> *Early Childhood Programs, National Museum*
> *of African American History and Culture*
>
> (Personal communication between Nicole Cromartie and Ariel Gory, August 13, 2020)

Gory has discovered that there are limits to how many and the types of families that we can serve if we're just planning programming inside of our museums. She's identified a challenge faced by many cultural organizations – it's not enough to have your doors open to welcome new (and historically excluded) audiences. Based on evaluation of early outreach efforts, NMAAHC has intentionally targeted neighborhoods that have encountered barriers to participation despite their close proximity to the Museum.

The examples set by these institutions, and others mentioned in this book, can serve as useful models, providing potential directions for museum educators who are interested in evolving their existing programming for families with early learners. But in the process of growing (or establishing) a program for early learners, it is vital for educators to be able to express the particular benefits of programming for this audience, to demonstrate the value of the program, and rally the support and resources of the institution. Here we return to the question – why serve very young children and their families in museums?

Once again, we can look to the institutions that have led the way in research, programming and evaluation for a litany of compelling answers to this question. The High Museum has for over 20 years invested an ever-increasing amount of resources in programming for early learners and their families in recognition of the fact that these programs have proven to be one of the most effective ways to achieve their mission. Within two years of opening to the public in 1928, the Museum had designated a special area for children. In 1968, the High introduced its first dedicated space for families to learn, play, and explore. Though a designated space for "children" had been in place for 40 years by this time, the development was significant because it aimed to engage the entire family, and placed children in a different context, alongside adult visitors. Staff at the High Museum have had conversations with adult visitors for whom participation in family programs are some of their earliest memories, and in some cases bring their own young children to story time programs led by the very same storyteller. In fact, it's not possible

to tell the story of the Museum itself without talking about children and families. In this historical context, when one reads the High's current mission, "The High Museum of Art collects, interprets, and preserves works of art, striving to engage and educate its local, regional, national, and international audiences, while promoting scholarship through research and publication," it's abundantly clear that families and young children are an integral part of the audience referenced. This is particularly palpable when one considers the long-term fostering of lifelong learners who grow to become adult museum visitors, and caregivers to the next generation of museum learners.

Museums serve very young children and their families because museums are educational institutions. Museum educators recognize the rich and distinct opportunities to have a profound impact on this audience (cited throughout this book). Museums support young children's emerging needs and learning through various sensory experiences, free exploration, and play in partnership with caring adults. When children encounter various objects or artworks in the museum, they begin to make meaning of the world around them, and their place within it.

Programs for young children and their grownups can effectively serve both groups, supporting early language acquisition for our youngest visitors while also fostering community among new parents. By modeling how to interact with children in the galleries, museum educators can help adults feel more welcome and oriented in spaces that can be intimidating. Working with young children teaches us new ways to understand our collections and how we can program for audiences of all ages, making our museums more friendly and accessible to all. By intentionally programming for these first visits we cultivate and empower lifelong museum visitors.

For any museum educator looking to establish a new program for early learners and their families, it's always possible to tap into the demonstrable power of achieving the mission of the museum. From its foundation the National Museum of African American History and Culture identified early learners as a key audience. This is evident in the current structure of the Museum: at the time of writing, there are six staff members dedicated to early learning in the education department. Ariel Gory addresses the ways in which their work is uniquely able to address the mission of their institution.

The mission of the National Museum of African American History and Culture is to address racism, to support healing, and to build a brighter future. We know that our understanding of the world is developed in early childhood. Research tells us that when it comes to our beliefs about ourselves, others, and the world around us, what we

> *experience after age 8 is not necessarily a process of learning how to be anti-biased or anti-racist, but of changing to be so* [Winkler, 2009]. *Following those vital early years of learning, it takes a significant life event or lesson to address or change an entrenched belief.*
>
> *Early childhood programming became a significant part of the Museum when we acknowledged that we had the opportunity to prevent racism through our work in those early years. If we're going to try to fulfill our mission effectively, we can't just address the problem after it's been formed, we need to be preventative and progressive.*
>
> *– Ariel Gory, Lead Education Specialist for*
> *Early Childhood Programs, National Museum*
> *of African American History and Culture*
>
> (Personal communication between Nicole Cromartie and Ariel Gory, August 13, 2020)

The leadership at the National Museum of African American History have tapped into something fundamental. Using research, they can identify the age at which racist beliefs are formed, and focus their work in response, where they know they can make the biggest impact on preventing the development of those dangerous ideas. NMAAHC acknowledges that design for early learners is at the core of who they are, and the most effective way to achieve their institutional goals. What is so striking about this example, in which early learning research fuels strategies to fulfil the core mission of the NMAAHC, is that this practice could be applied to nearly any museum, regardless of the specifics of their mission. The NMAAHC uses the objects and stories contained within their museum to instigate complex and necessary conversations about race. Other museums are using their own collections to introduce other critical ideas that can help young children make meaning of the world. Within these conversations, young children are establishing skills in traditional literacy, visual literacy, and cultural literacy.

If every museum understood that 85% percent of brain development occurs between birth and 3 years old, they might see the power and potential in investing in quality experiences and ongoing evaluation for this audience. As more museums across the globe begin to realize that planning for our youngest visitors is not just another educational initiative, but is in fact, critical for fulfilling their missions, programs like Toddler Thursday and the other programs discussed in this book will be viewed as necessary for their survival and continued relevance. Early learning programming is not merely a "nice to have" – it's one of the most effective ways to realize the

promises made in our missions. Consequently, it should not only be done, and done well (informed by research and in collaboration with experts and community partners) but also warrants high-quality evaluation.

The evaluation of the Toddler Thursday program began as a project to determine how museum educators at the High could improve the program to better serve their family audiences. The unforeseen result was that, rather than the museum changing aspects of this program for children, ultimately, the children and their families changed *the museum* – and did so across many areas of museum work. As evidenced by the insights from other museum educators from across the globe in this book, that situation is not unique to the High Museum. Serving young children in your museum will not only be critical in fulfilling your mission, but will positively shape everything you do as an organization.

References

National Museum of African American History and Culture. *About the Museum.* https://nmaahc.si.edu/about/museum

Winkler, E. N. (2009). Children are not colorblind: How young children learn race. *PACE: Practical Approaches for Continuing Education,* 3(3), 1–8. www.academia.edu/3094721/Children_Are_Not_Colorblind_How_Young_Children_Learn_Race

Index